England / Scotland 1960

Bruce Davidson

England / Scotland 1960

Steidl

A Time Line
Bruce Davidson

1956 – 1957

When I was twenty-three and stationed in the Army outside Paris, I was introduced to the 'Widow of Montmartre' by a French soldier who became a friend of mine, Jean-Pierre Collin. Madame Fauchè was ninety-two when I first met her. Her husband was Leon Fauchè, a French Impressionist painter, who, I was told, knew Gauguin, Lautrec, and Renoir. The widow lived alone in her skylight garret with many of her husband's paintings placed on easels or hung in frames on the walls. That she was a remnant of the past era in Paris drew me close to her and for several weekends I visited her.

It was at this time that I met Henri Cartier-Bresson. I made an appointment at the Magnum Paris office to show him my pictures of the widow. I remember how surprised I was to see the man who'd photographed for years in India and Africa and rural America so elegantly dressed in a brown tweed sports jacket and beige slacks. He sat very erect on a stool looking intently at my contact sheets and the prints I brought. He continued to be a mentor to me and the depth of his immense archives inspires me to this day. It is the discipline implicit in his work plus the spirit and passion of his life that has been a touchstone for me over the years.

1958

I joined Magnum Photos. Then I traveled for several months with the Clyde Beatty Circus. At that time tent shows were dying out and were being replaced by steel and concrete coliseum shows. I became friends with a dwarf clown called 'Little Man' whose real name was Jimmy Armstrong. At the end of those days, I gave Jimmy a miniature sized camera that he could hold in his small hands. He sent me his circus route card until he later retired. He died before I could see him again.

1959

I was coming to the end of an intense photographic encounter with a notorious gang of teenagers in Brooklyn called 'The Jokers'. I had decided it was time for the photographs to be put together for publication in a national magazine and the moment for me to move on. These photographs of the teenagers revealed their depression, anger, and isolation from a community that had abandoned them. Most of the families were poor, often dysfunctional, and the youths were left to fend for themselves on the asphalt streets. I responded to their aloneness and often showed them their own pictures or brought in photographs I had made at Cape Canaveral of a rocket launching, or of professional wrestlers made on assignment, or other images that would give them a view into a world other than their own. The editors at *Esquire* agreed to publish several of the gang pictures, but asked me to obtain model releases from their parents or guardians. I teamed up with the leader of the group, Bengie, to go around the neighborhood, late one night, to collect written permission from parents for pictures that would appear in the magazine. I was given some cash from the magazine that I gave to Bengie to distribute to the few members of the gang who would appear in print. A few days later I began to receive threatening phone calls from raspy voices I didn't recognize, asking about the money and to whom I gave it. I became apprehensive,

expecting the worst scenario because I knew organized crime lurked in the community.

1960

Magnum New York had obtained an exclusive commission to document the making of a major film called *The Misfits* directed by John Houston. It was written by Arthur Miller and featured his wife, Marilyn Monroe, as well as Clark Gable, Montgomery Cliff and other talented actors. Several Magnum photographers including Cartier-Bresson, Eve Arnold, Elliot Erwitt, Ernest Haas, and myself, took turns of about ten days each at the Nevada desert locations.

During one scene Marilyn was to ride a horse. In the corral she began to ride slowly around when suddenly the horse stepped on a piece of barbed wire lying on the ground causing it to buck. As the horse started to rear Marilyn began to lose her balance. Both Miller and Houston rushed to settle the animal and help Marilyn safely off. When it all happened, I was perched on the top rail of the corral fence ready to take pictures of Marilyn riding the horse. Marilyn passed by me asking inquisitively, "Bruce, did you get those pictures?" I replied, "No Marilyn, I don't take insurance pictures." Later, I learned that she was impressed with my reluctance to exploit the situation, and she spread the word around the company that I could be trusted.

When my stint covering the making of *The Misfits* was over I was anxious to return to the reality of New York. It was good for me to get away for a while, but after ten days I had had enough. I was eager to return to the street life of the city.

Around this time, Cornell Capa, a fellow Magnum member and later founder of the International Center of Photography, urged me to get out of the country on an assignment that would allow me to be free and to work without any editorial agenda. He suggested that John Hillelson, our agent in London, obtain an assignment from *The Queen*

magazine to bring me over for a couple of months to explore England and Scotland. *The Queen* was a cultural magazine dedicated to British life style. Going over to Britain and roaming the countryside appealed to me. I would not feel the fear in Britain that I had in Brooklyn, or be immersed in the fantasy world of Hollywood film.

In preparation, I asked a local tailor to enlarge the pockets of my Seersucker sports jacket so I could place a Leica camera in each of them. I would still hold one camera in my hand, ready to react to any fleeting moment. With money I had saved, I purchased a small Hillman Minx convertible coupe with soft red leather seats to drive around England. I planned to take it back to the States once the commission was completed, so I purchased it with the steering wheel on the left, as it is in America. This made passing other vehicles on British roads harder, but while driving on the left, I was able to photograph people out the driver's side window. I sometimes startled people along the roadway steering and snapping.

Soon after my arrival there was a meeting at *The Queen* with the editor-in-chief, Jocelyn Stevens; editor, Beatrix Miller; art director, Mark Boxer; and others. They agreed that I should stay unattached, but suggested I visit Hastings, Brighton, and a few destinations in Scotland. Stevens invited me to stay at his family homestead in Pitlochry, Scotland, and arranged an introduction to his gamekeeper, Bunty, who would give me a tour of the estate.

Before I left for London, I had received a commercial commission for a corporate brochure to make an action portrait of a distinguished-looking executive by the name of Campbell at the Philadelphia Stock Exchange. When I happened to mention my forthcoming visit to England and Scotland, Campbell suggested I look up his cousin, the Duke of Argyll, at his castle in Inverary and gave me the Duke's address and phone number in Scotland.

John Hillelson thought I should spend several days in London

before exploring the countryside and arranged for me to do a series of *Drink a Pint of Milk a Day* advertisements. I photographed a tradesman with a bottle of milk placed in his bicycle basket while riding to work, and a couple of other milk situations around London.

John showed me the remnants of several bombed-out buildings now used as a "car park". It brought to mind the War and the devastation that occurred just fifteen years earlier. I had learned about the bombings as a youth from BBC radio broadcasts and from copies of *Life* magazine I saw while growing up in the heartland of America. Observed in this ruin was a classic silver Bentley along with more modest British vehicles. A man was seen strolling with his pet dogs through the maze of broken walls and building foundations. It gave me a sense of how the British had survived and made the best of things; how they were able to go on with their lives and hold on to their culture in spite of the turmoil and adversities they had faced in wartime.

I walked around central London to Throgmorton Street and the Stock Exchange where I saw two men wearing top hats, one carrying an umbrella, briskly walking together. I thought to myself how distant from my own experience was this need for a formal dress code that set one apart from others in this class system. Walking further, I discovered a small sweet shop selling delicious-looking fudge. I purchased a bag and ate it as I strolled along London streets taking pictures. On another day, I found myself in a dim and dusty tomb in the nave at St. Paul's where I happened upon a woman paying her respects to a bronze memorial of some notable lying in state. It reminded me of childhood family visits to the cemetery where my Grandmother was buried. We had lived with her in the village of Oak Park, Illinois just after my parents' divorce. When the headstone was unveiled, there was a small hand-colored porcelain picture cemented to it. It was hard to come to grips with the frozen likeness on the headstone, replacing the maternal warmth of my Grandmother.

One day, I entered a public reading room in Hastings and came upon an elegantly dressed elderly woman wearing strands of glistening white pearls while standing at a stall reading a daily paper. I thought how dignified and self-contained she appeared yet wondered why she didn't buy a paper on the street and take it home to read. In Regent's Park, children played among the dense shrubs and under the broad canopy of solid shade trees. Their play made the park an enchanted place, full of magic and mystery. I recalled as a boy after my Mother re-married and we moved to a larger house in River Forest, ambling through the forest preserves across from our home to a trailside museum where birds and ground animals were on display. I often visited there to take pictures. While traipsing through the woods, I was held in a state of awe in this nature preserve. At the age of sixteen, I photographed a young barn owl in a cage at that museum. The photograph I made of the owl later won First Prize in the Kodak National High School Snapshot Contest in the Animal Division. As a teenager, this recognition gave me support and encouragement.

One evening, I met a group of young people on a street corner in London. One of them was a winsome girl with a sleeping roll slung around her who was gently holding a kitten while fixed on something in the dimly lit London street. She reminded me of Cathy from my 1959 *Brooklyn Gang* series. I had photographed Cathy combing her hair reflected in the cigarette machine mirror at a public bathhouse in Coney Island. Both young women were lovely and open to life. The group took me to a dilapidated old-time dance hall where sets of drums were beating loudly and young people were dancing. I stayed for a while but finally said goodbye to the group and left for my cheap hotel in Bayswater to get ready for the next day.

After a couple of weeks in London, I decided to head for the town

of Hastings by the sea. It was good to get out of the gritty fogs of London. The city had an effect on me that was claustrophobic. I needed the open countryside and the sea, and to drive in my new convertible with the top down. In the passenger seat I placed a bag of fudge from the Throgmorton sweet shop, a can of breakfast digestive biscuits and a bunch of yellow bananas. I drove with cool fresh air rushing across the open road as the pastoral landscape scrolled by. Hastings had the classic seaside quality that I hoped to find. In the overcast light, I made pictures of three women taking tea out of the boot of their parked car, young boys traversing the steep and stony cliffs called 'Lovers Leap' and a woman all by herself on the boardwalk sitting in a wheelchair wearing a cape and a rain hat. It gave me an eerie feeling seeing her silent and alone.

After a few days, I continued on to the seaside resort of Brighton. There I walked on the pebbled beaches where people set up wooden beach chairs and spent the day looking at the expanse of gray ocean and life along the strand under the opal sky. It was the way they placed themselves, sitting still on these beaches and boardwalks, that was peaceful to see. These were the stoic survivors of the Second World War.

From the boardwalk, I could see a man reflected in a large dresser mirror set on the beach. He looked out towards the horizon. Leaning along-side the mirror were two hand-written signs reading "Cockles and Whelks". I didn't know what they were at the time. I could see a few fishing boats laid up on the beach that added to the strange quality of a scene that moved me. In the far distance, I could see the pavilion at the end of the long, steel pier jutting out into the ocean. Its neon sign reading "Palace of Fun" was just visible in the after-light. This view, the ocean air, and the vastness of the sea merged with an image of coastal England, became imprinted in my mind.

I began to realize that my view of England and Scotland was not going to be that of Big Ben, the Tower of London, or the Changing of the Guard at Buckingham Palace. It was to be more about people seen on the streets of London or in the rolling landscapes. It was about people having lunch in tiny London sandwich shops, people strolling on the wet sand when the tide was out, having formal tea along the seaside, ladies in white playing bowls on manicured lawns, or sheep herders with their obedient dogs along the moors. It was a personal quest I was having in a country with a rich history. I soon realized that I could not possibly convey it all. I could only follow my instincts and trust my intuition wherever it led me over the months of exploration. Perhaps it was best this way, and certainly more natural to me.

Around this time, John Hillelson suggested I head up to Scotland for the Oban Games. There I photographed the hammer throw and other medieval sporting events that were a little boring for me because I had little historical context for them. So, I decided to call the Duke of Argyll at his castle in Inverary not too far away. I dialed the number and someone officiously answered the phone. I said, "Hello, Duke?" The voice on the other end paused and then asked, "You mean His Grace?" I explained I was an American photographer on assignment for *The Queen* magazine and would like to talk to the Duke of Argyll. The voice asked me to wait for a moment. In a few minutes, the Duke answered the phone. I explained that a stockbroker in Philadelphia gave me his number and said he was a close cousin. The Duke broke in and exclaimed that he had hundreds of cousins around the world claiming to be closely related to him. I further explained that *The Queen* magazine had brought me here to photograph for a special issue on England and Scotland. He said that he would be away for a few days but invited me to stay at the castle until he returned.

The next day I found myself in the stone castle alone with the butler. That evening as I sat at an immense dining table, I was served dinner by the butler. He dished out hot mashed potatoes from a

heavy, sterling silver serving dish. He was wearing a tuxedo with long tails. As he held the dish, I placed my hand under his to steady it. He glanced at me as a slight smile appeared on his tight lips. The Duke arrived late the next evening and in the morning we had breakfast. Earlier in the morning, a bagpiper played along the staircase leading to the bedrooms as a wake up call. His Grace wore a plaid wool "dressing gown" and sat at the head of the dining table, but since I didn't have a dressing gown, the Duke had the butler deliver to me a spare.

The next evening Sir Colin Barber, the head of the Black Watch, arrived with his wife, Lady Barber, and the Duke's young son. We all had dinner together and then sat by the fire. The Duke asked how he could help me with my assignment for *The Queen*. I asked to be put in touch with a shepherd. In the morning it was arranged that I visit the islands of Mull and Iona to stay with farm families that he knew. They quickly took me in as if I were a member of their immediate family. At the end of a long day in the wind and cold, herding sheep and tending to the farm, the shepherd and a helper sat at the kitchen table deep in their own thoughts and daydreams. I can remember to this day the damp cold penetrating to the core of my bones. In their stone house on Mull, the shepherd's wife was kind enough to give me a rubber hot water bottle to take to bed. In the early morning drizzle the shepherd strode across the moor carrying his staff, herding the flocks with his sheep dog rhythmically weaving back and forth.

After a couple of months I returned to New York and to my one room skylight in Greenwich Village, where I lived alone. There I edited the one hundred and eighty-seven contact sheets, approximately six thousand seven hundred exposures, from England and Scotland. I began making prints in my kitchen-darkroom combination with a sliding door that kept out the light. I had placed a ruby-red safelight bulb in the refrigerator so I could print and nibble on cold chicken and frozen Hershey bars during the day and much of the night. In those days, I slept on a foam-rubber mattress on the floor, made a small fire in the fireplace, took care of my eight-foot, potted and dying schefflera tree, and photographed around the city, particularly the Lower East Side and Central Park.

1961 – 1965

I received a Guggenheim Fellowship to document "Youth in America" in 1962. In the year before, John Morris, the then bureau chief at Magnum New York, told me about a group of youths who were challenging the segregationist laws of the South that prohibited integrated travel. Federal law stated that integrated travel on federal highways was legal and would be upheld. A busload of "Freedom Riders" at Anniston, Alabama had been beaten when they arrived, and the bus was burned. The "Freedom Riders" were then arrested. At that time there was no police protection and no press coverage. When I learned of this violence I decided to join the next ride that was to leave from Montgomery, Alabama to Jackson, Mississippi. The night before we boarded the buses for Jackson, I went to the home of a local pharmacist to meet with the group of "Freedom Riders" who were planning the trip. There I met with one of the leaders, John Lewis, who had been seriously beaten at Anniston and had a large bandage on his head. He also continued on this second trip. Years later, he became a Representative in Congress for the State of Georgia and is a respected political leader working for equality and justice.

I photographed the Civil Rights Movement from 1961 to 1965, attending many protest marches and demonstrations including Birmingham in 1963, the Washington March in 1963, and the Selma March in 1965. I bore witness to the human degradation that permeated the South and the North at that time.

1966 – 1968

I began photographing on "East 100th Street" in East Harlem from 1966 to 1968. At that time, local citizens' committees were formed to improve run-down housing, create social services, build new schools and revive their community.

In 1973, I photographed in a restaurant on the Lower East Side called "The Garden Cafeteria". There I met survivors from the Holocaust and from the city itself. In the late seventies, I began photographing in the New York City Subway system. At that time, the trains, stations, and passageways were in poor condition, full of graffiti and abuse. The Subway was unsafe and people were held hostage to this deplorable mass Transit System. Beginning in 1992, and continuing for four years, I wandered through Central Park exploring this 842-acre habitat and getting to know the birders, the homeless, and the layers of life that exist in this diverse urban oasis. This space relates to man and nature coming together in the city.

Looking back, it seems many of the worlds that I have entered over the years have been in transition. The people in these worlds-within-worlds have often been isolated and invisible. I've had the privilege of being an outsider allowed on the inside, searching for beauty, meaning and myself.

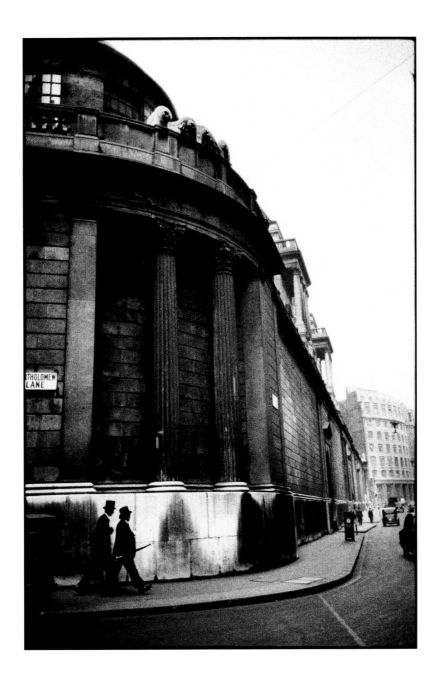

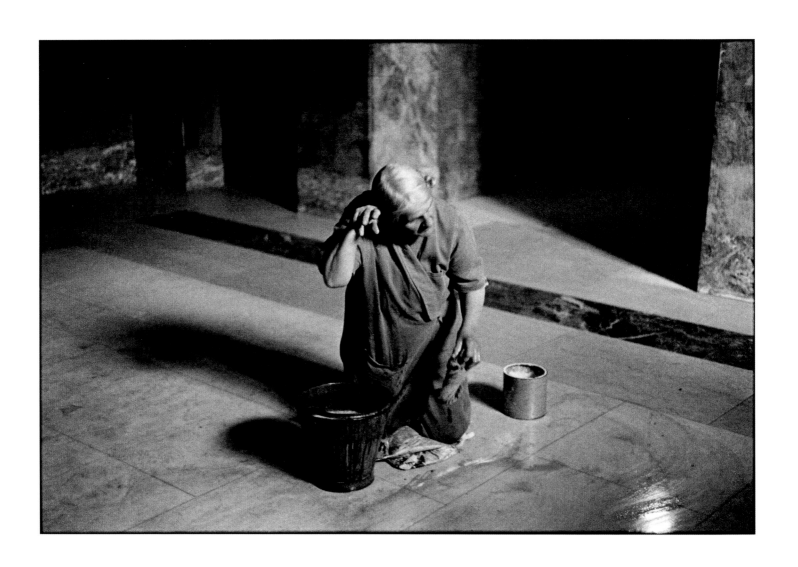

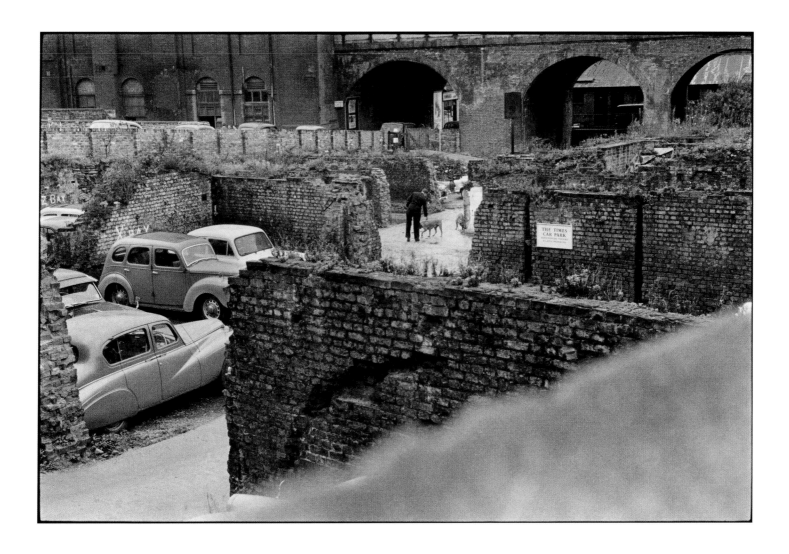

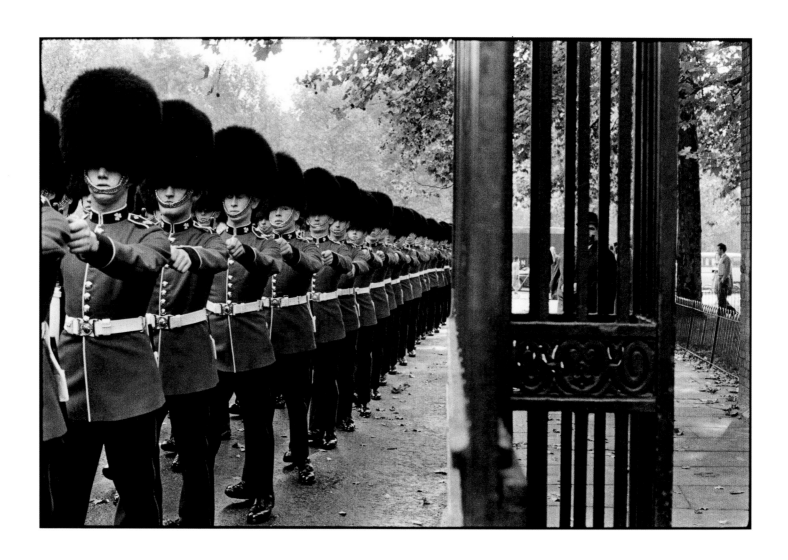

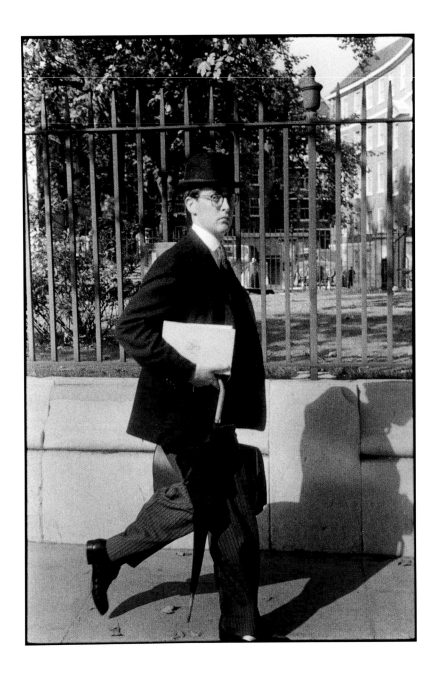

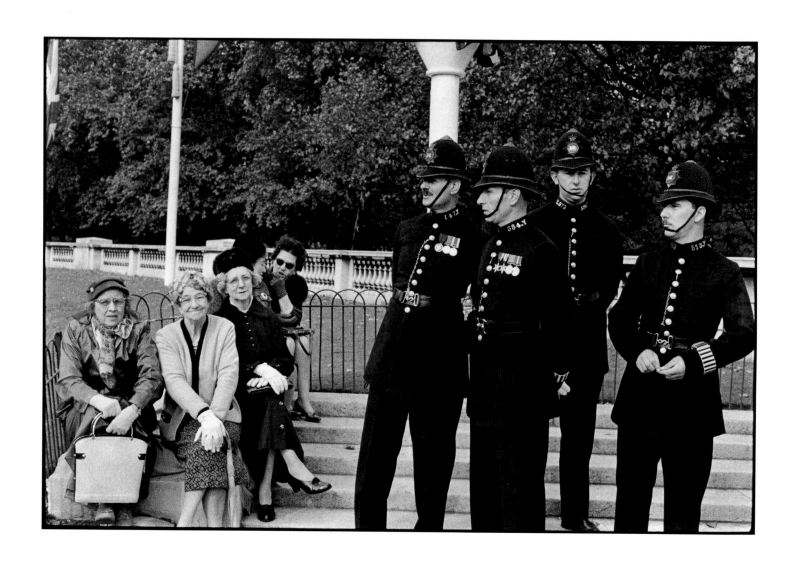

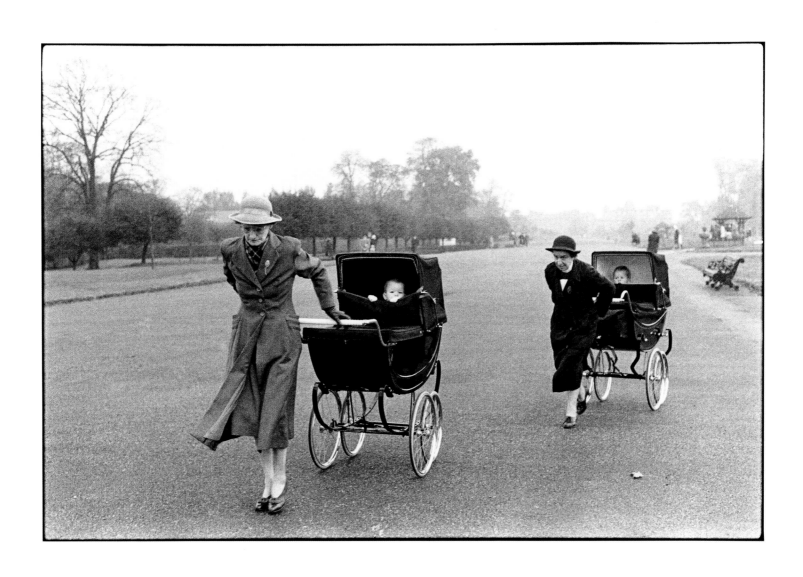

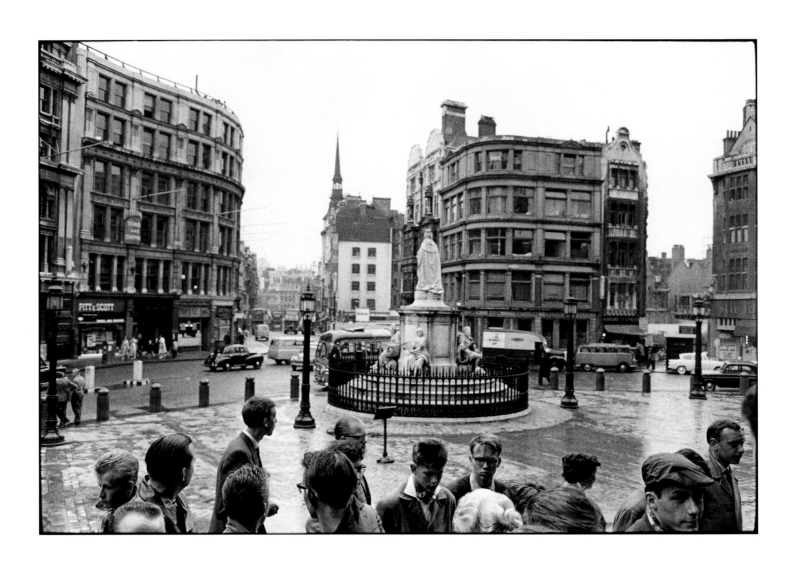

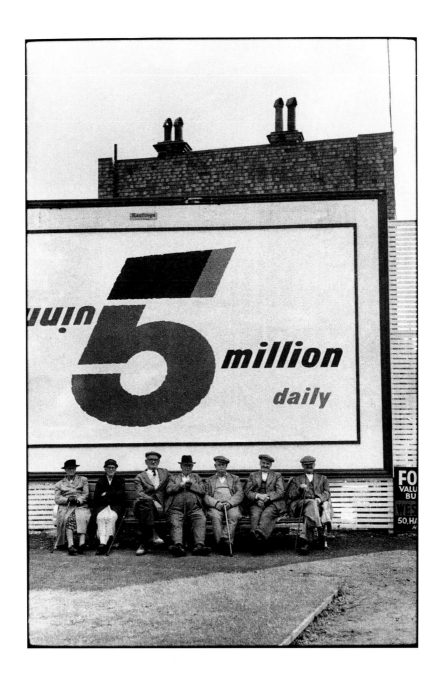

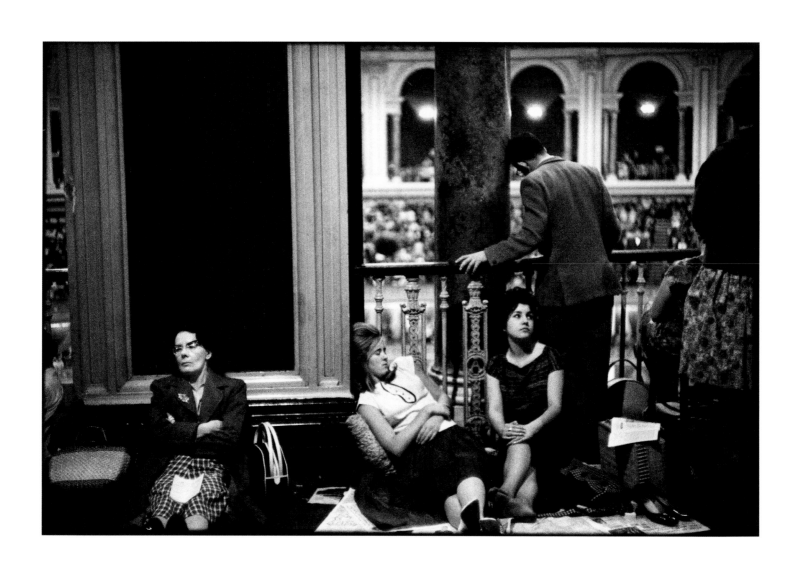

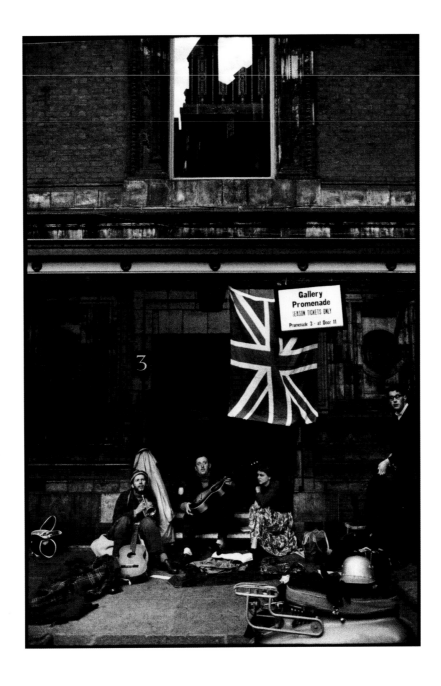

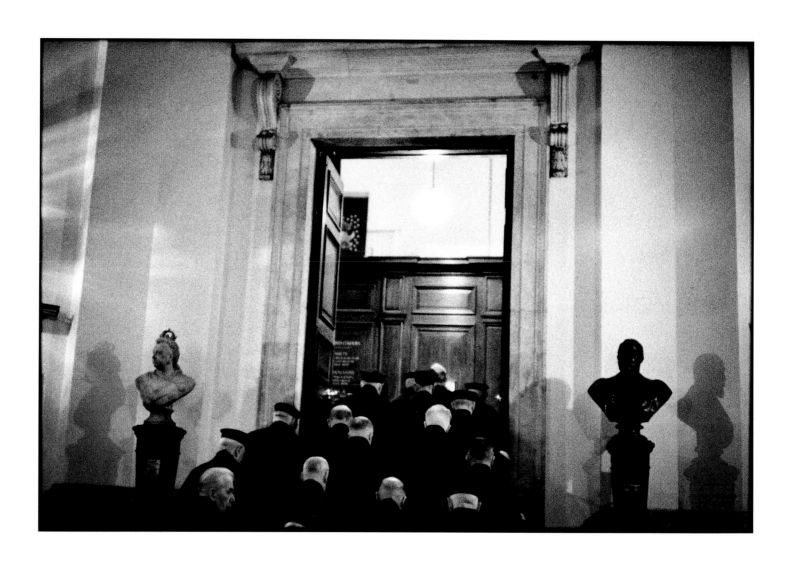

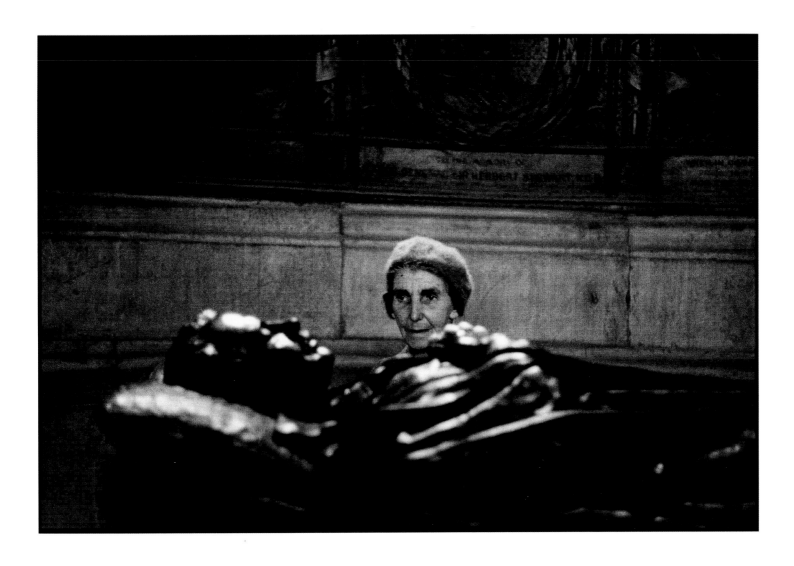

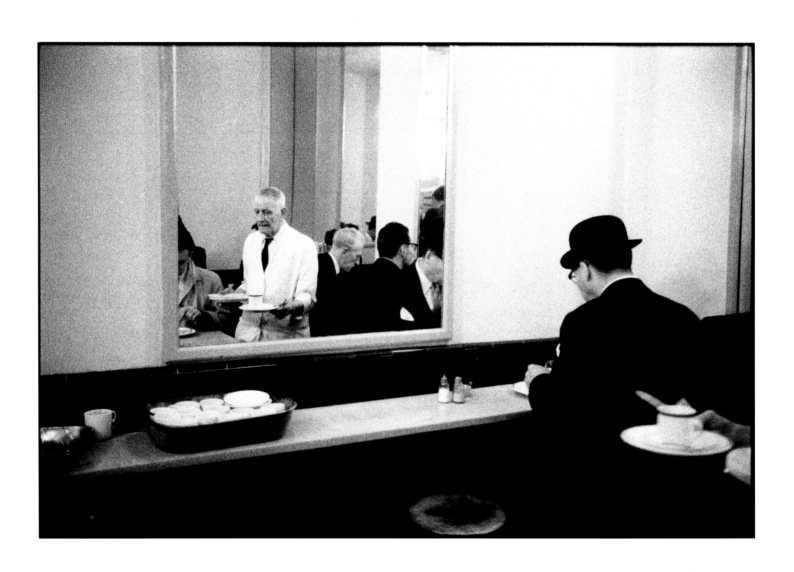

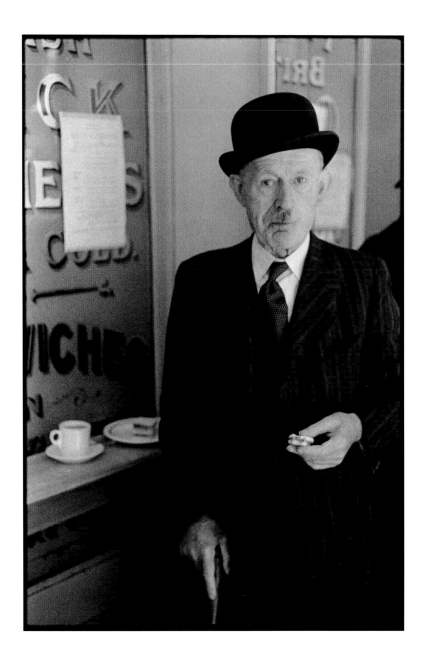

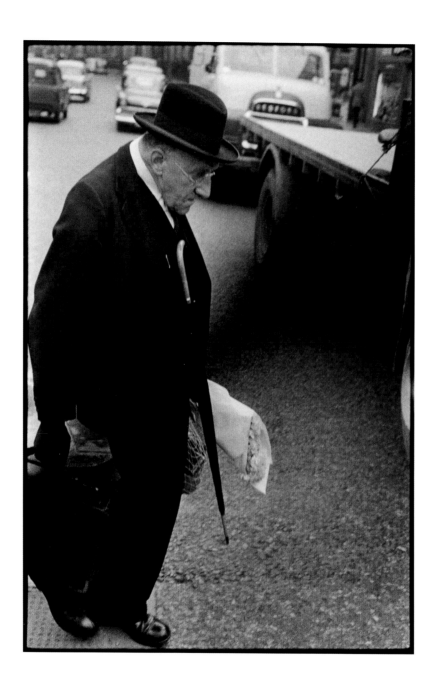

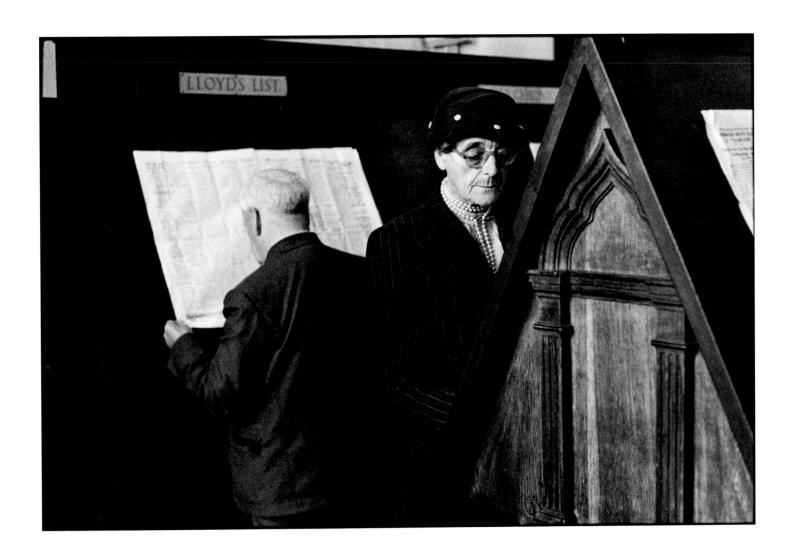

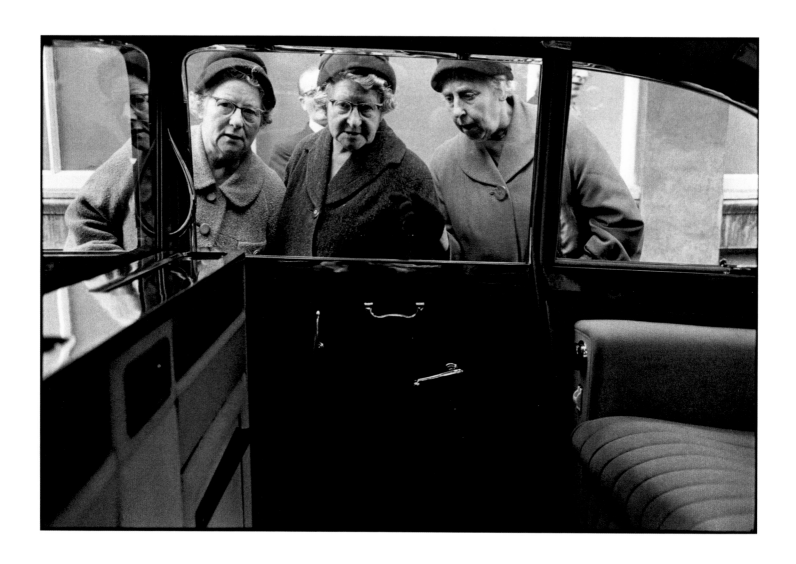

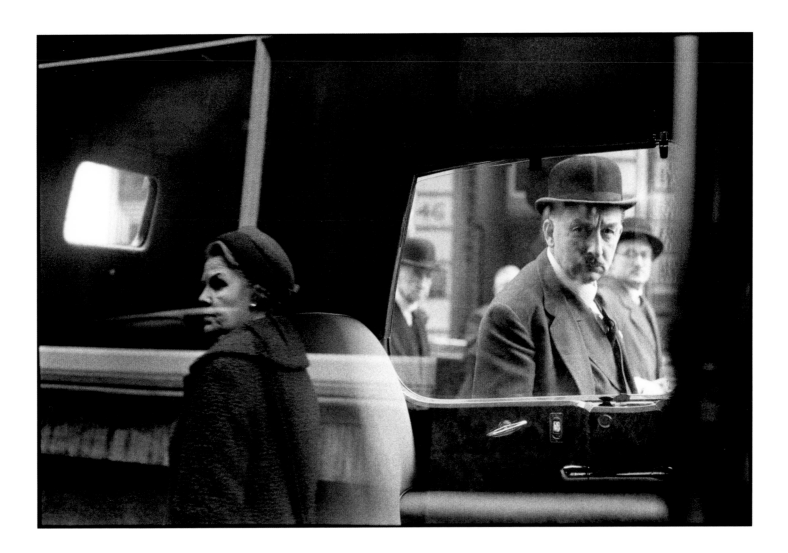

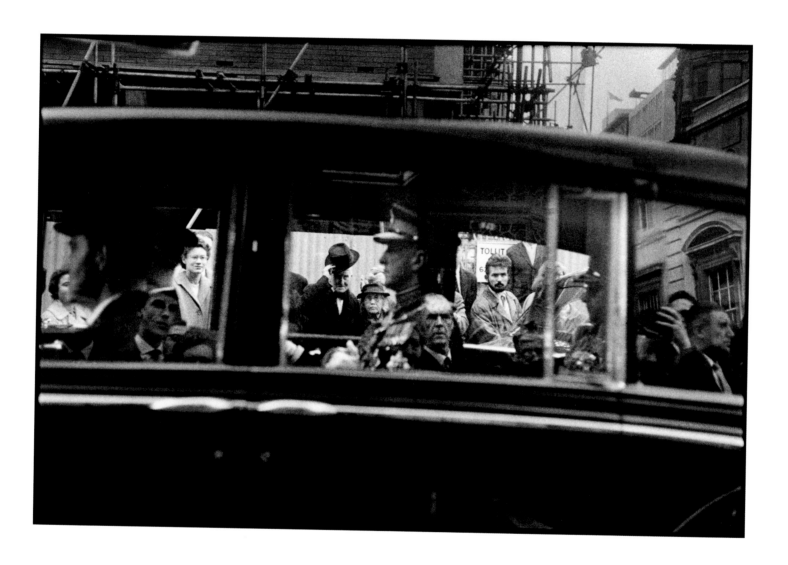

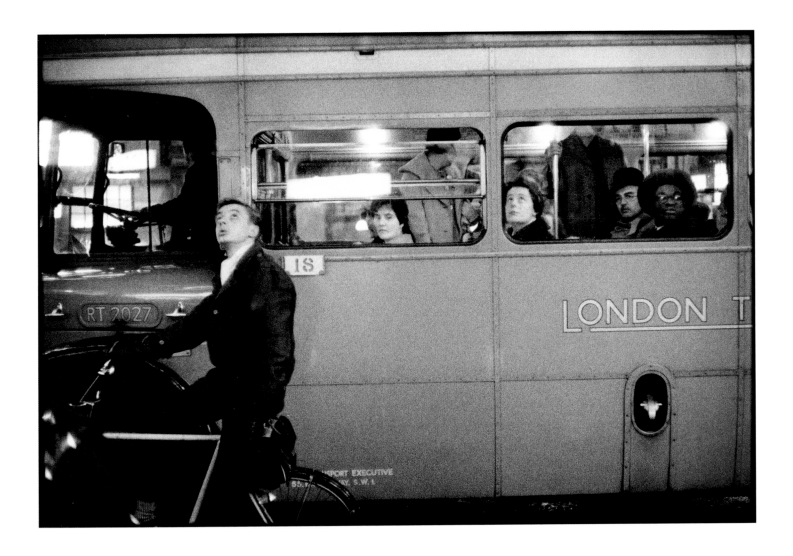

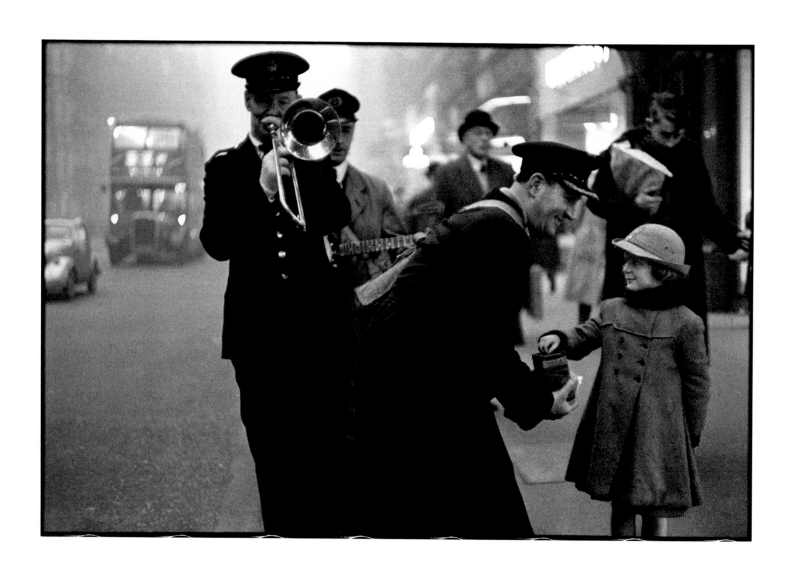

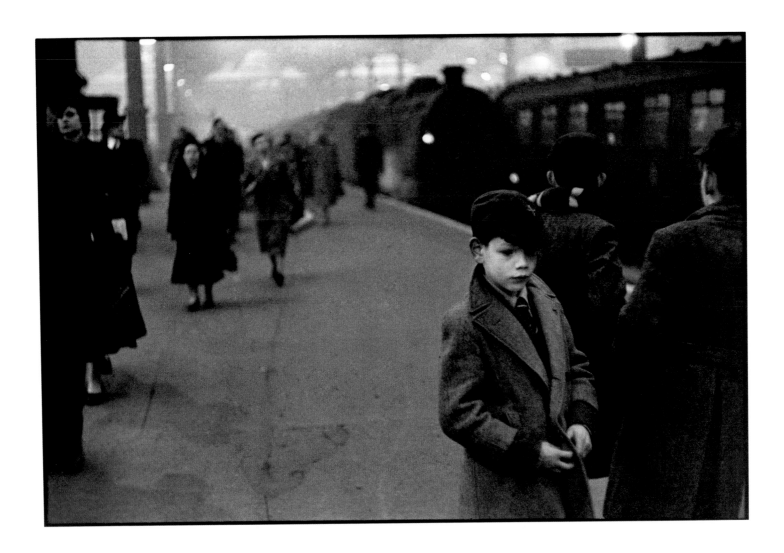

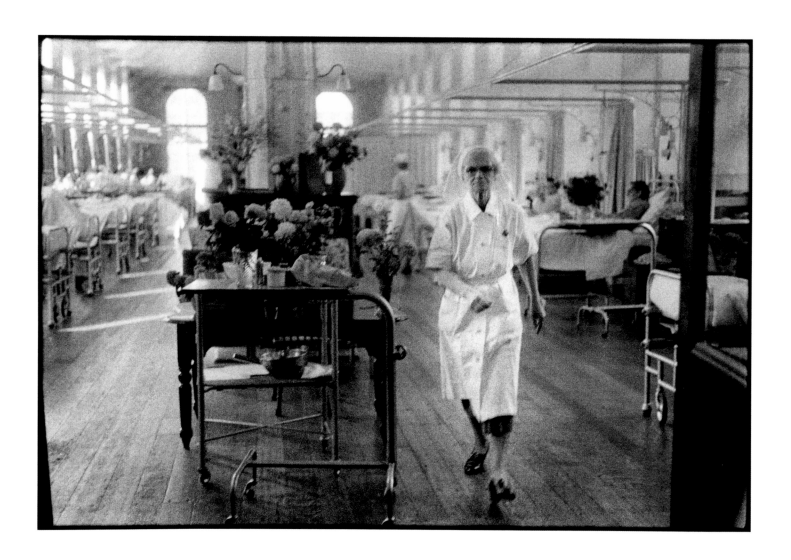

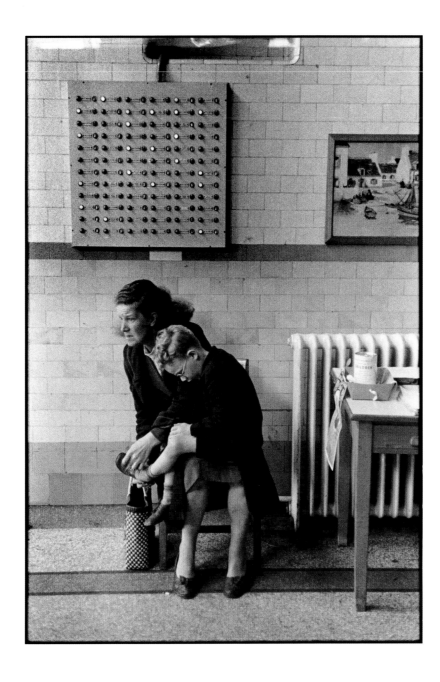

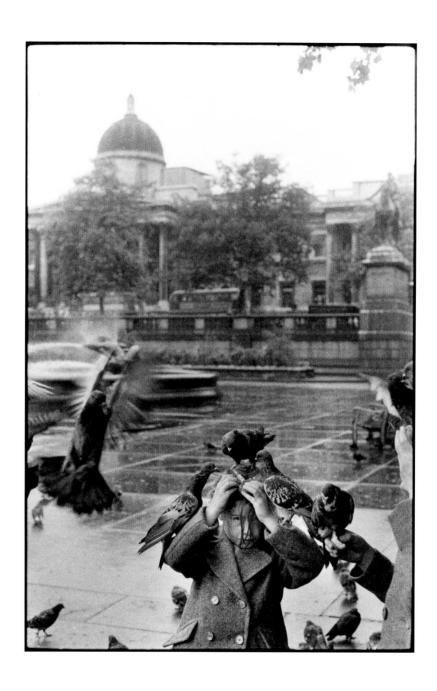

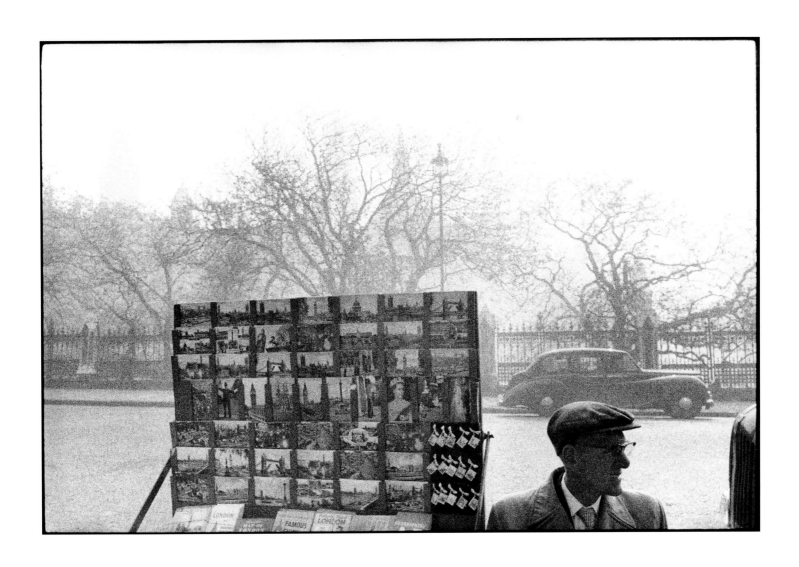

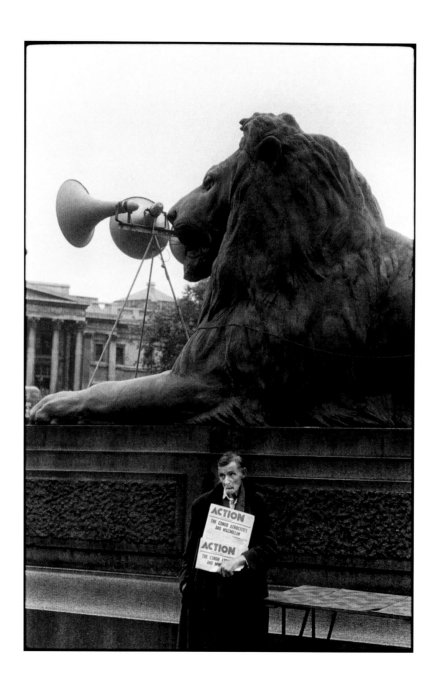

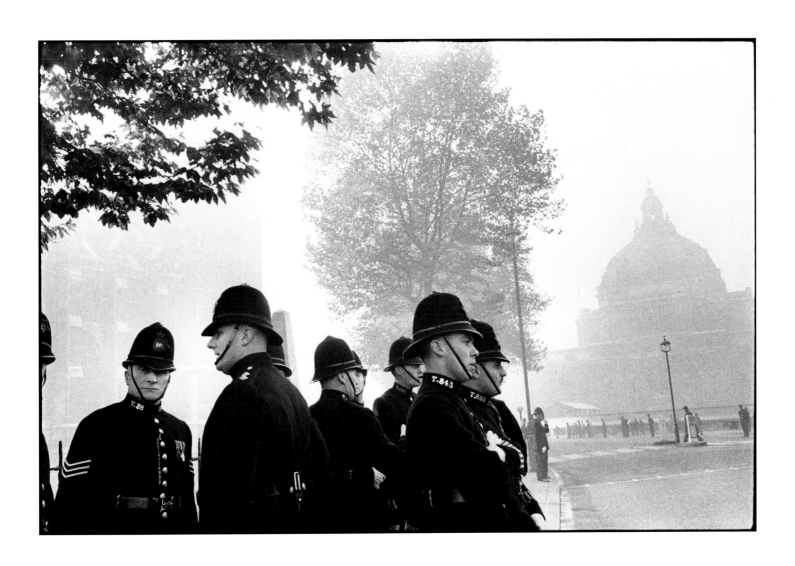

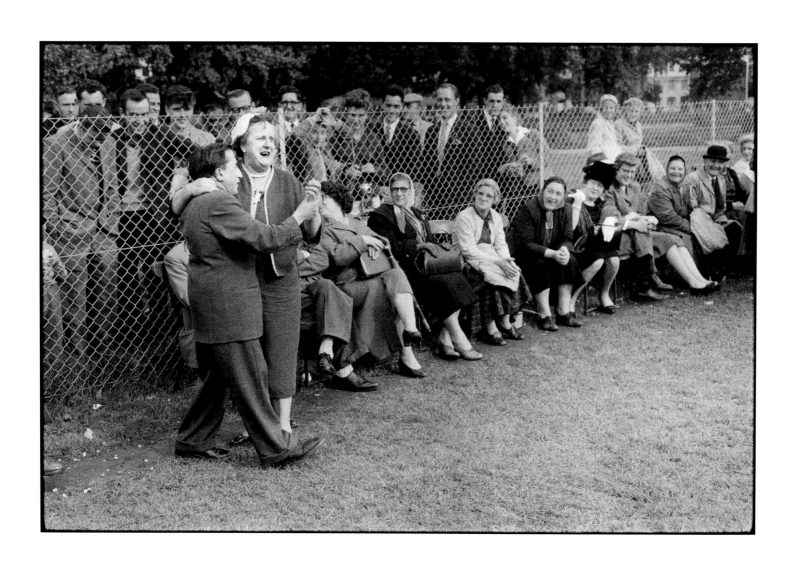

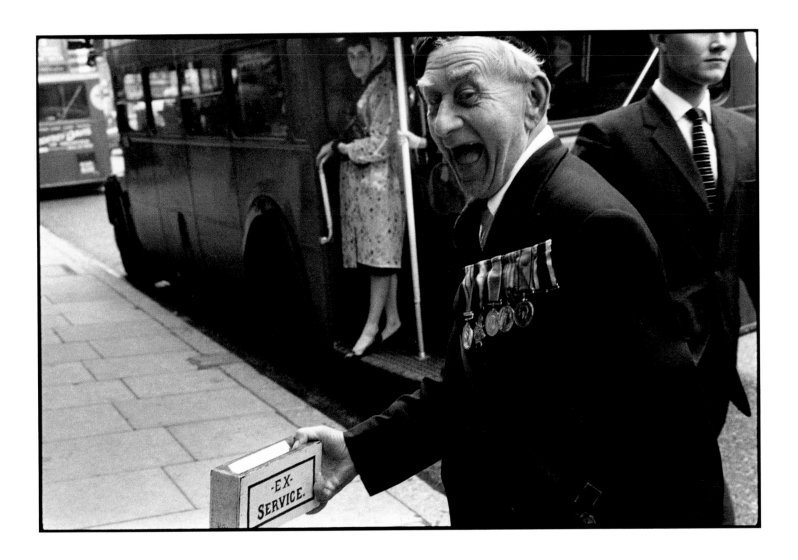

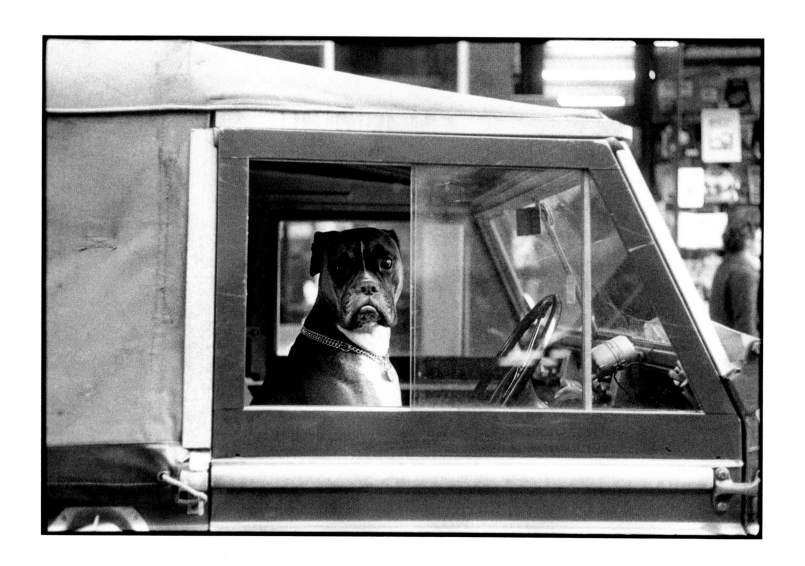

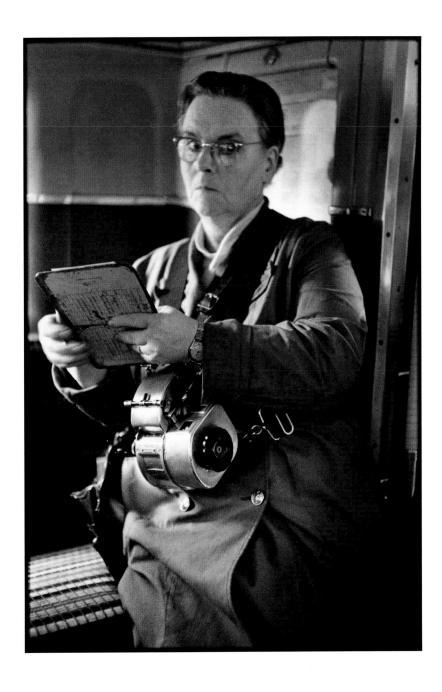

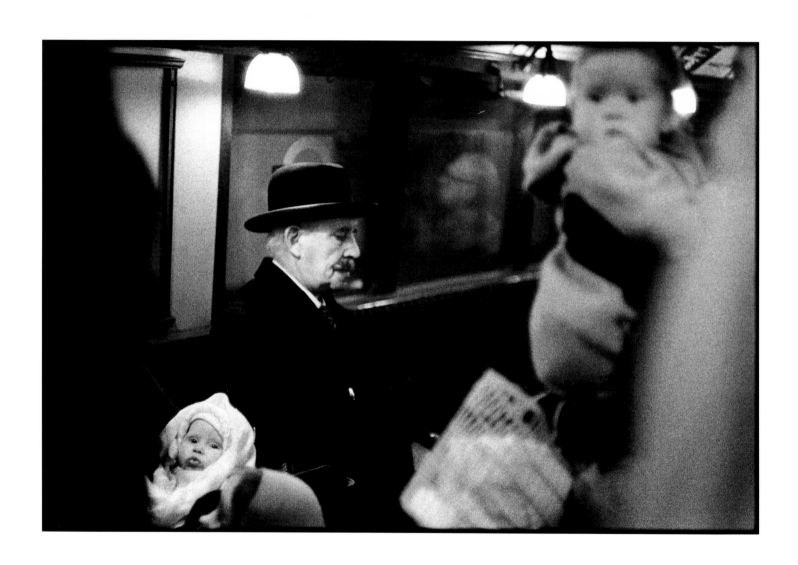

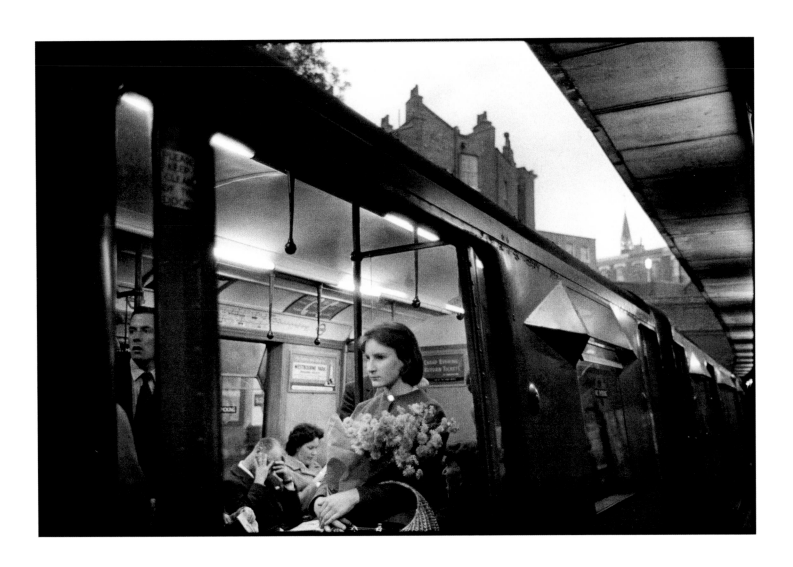

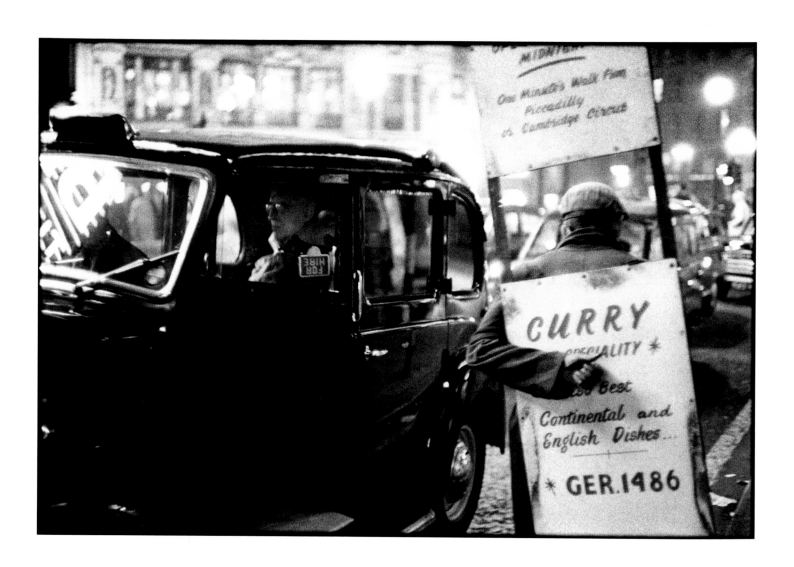

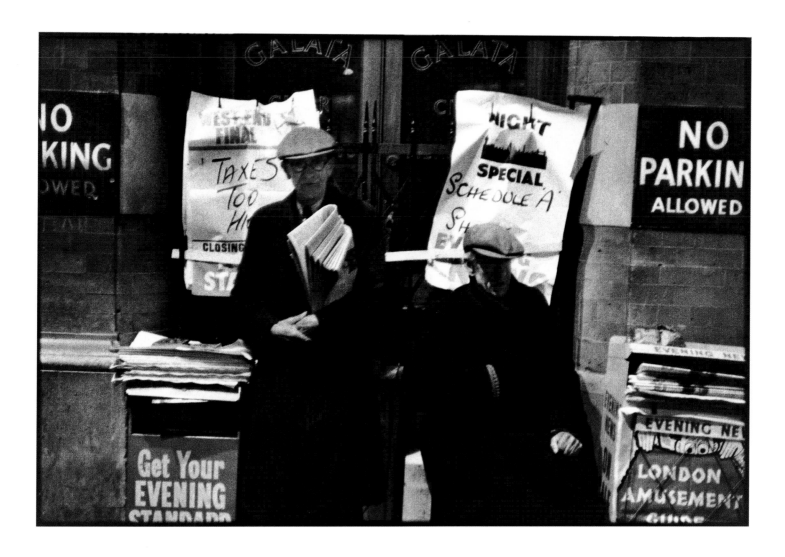

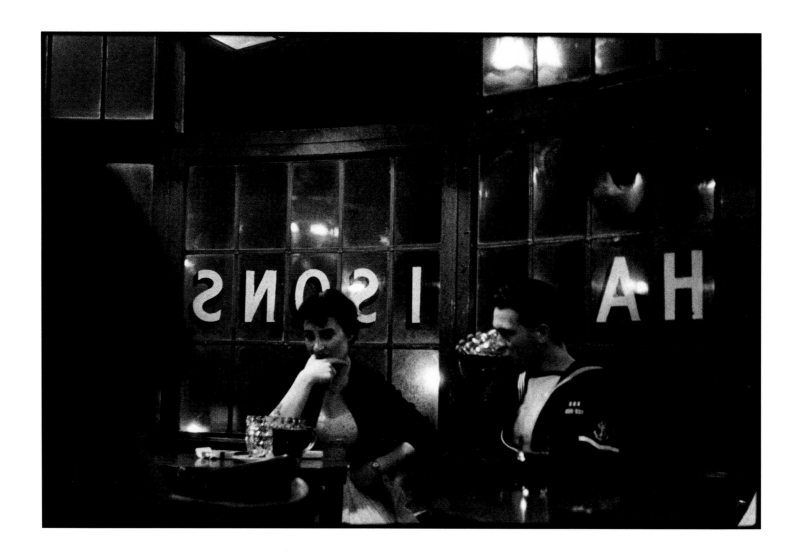

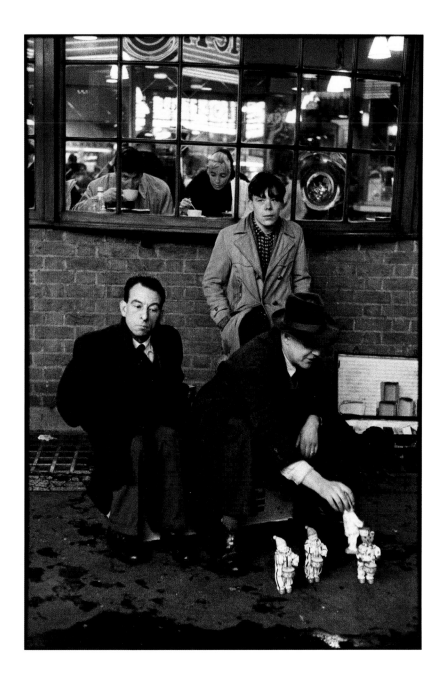

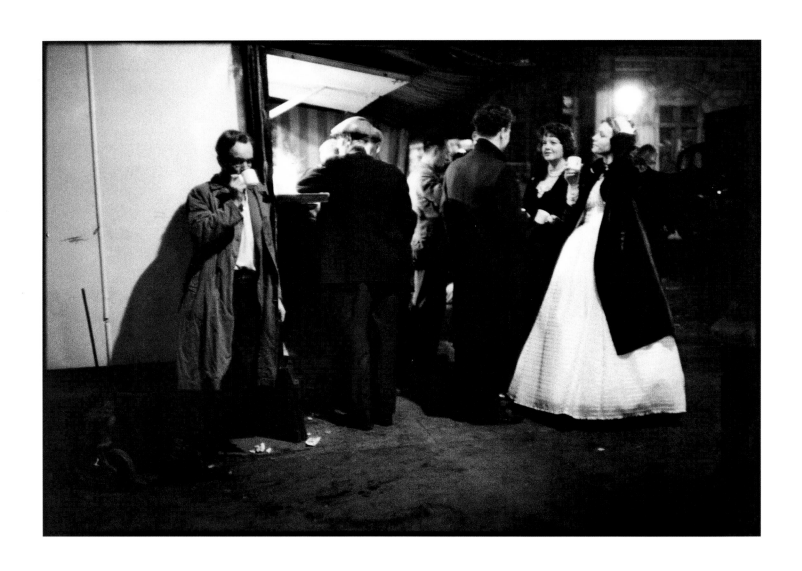

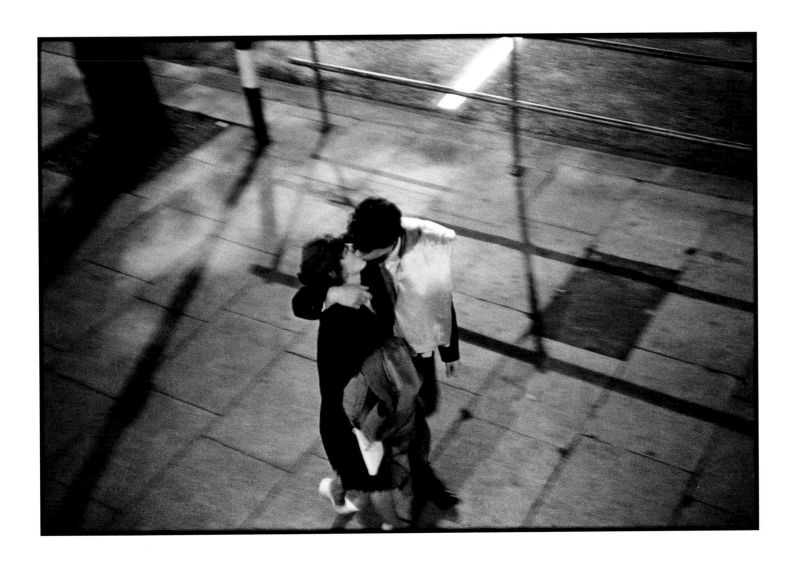

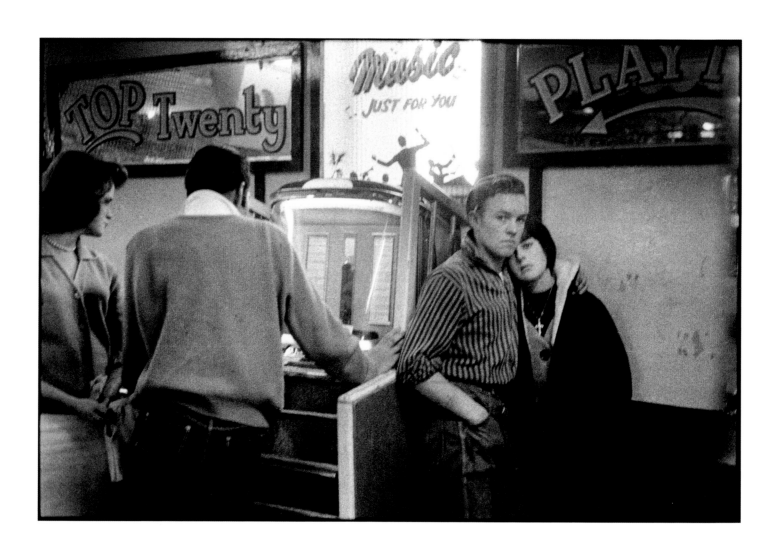

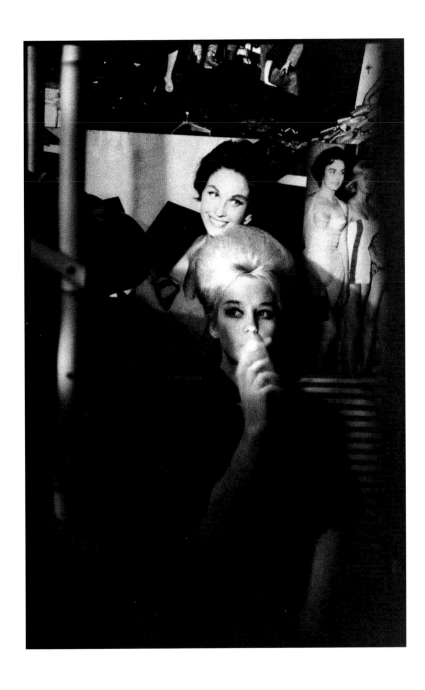

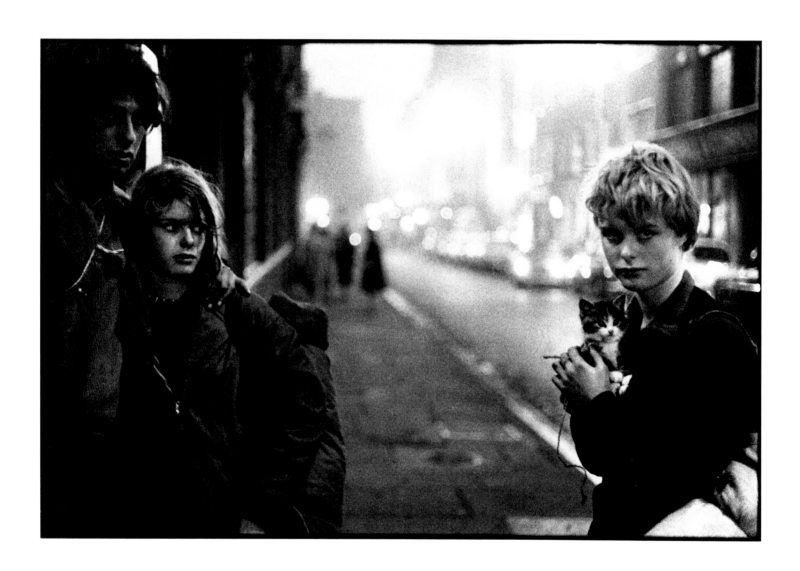

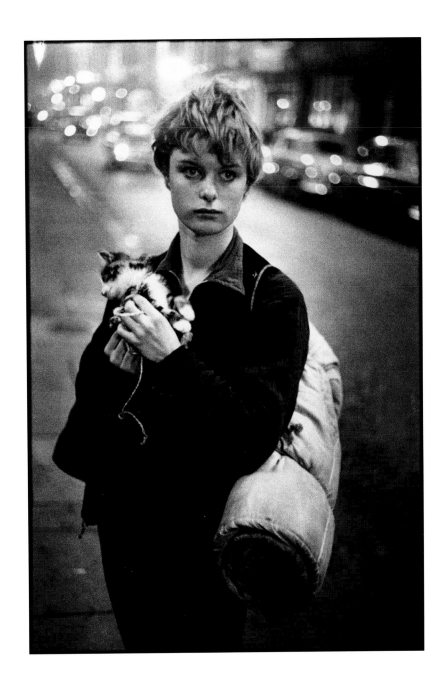

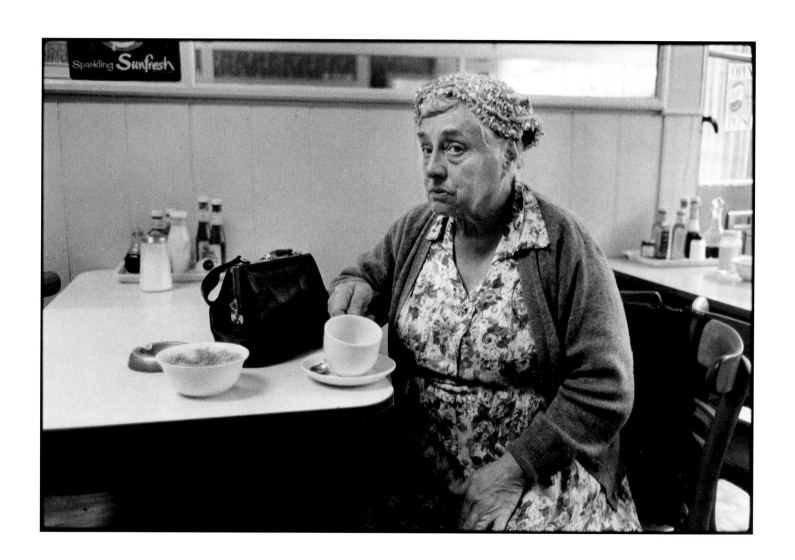

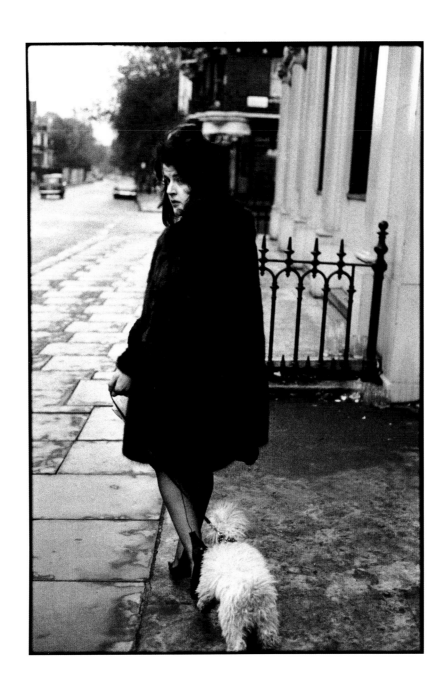

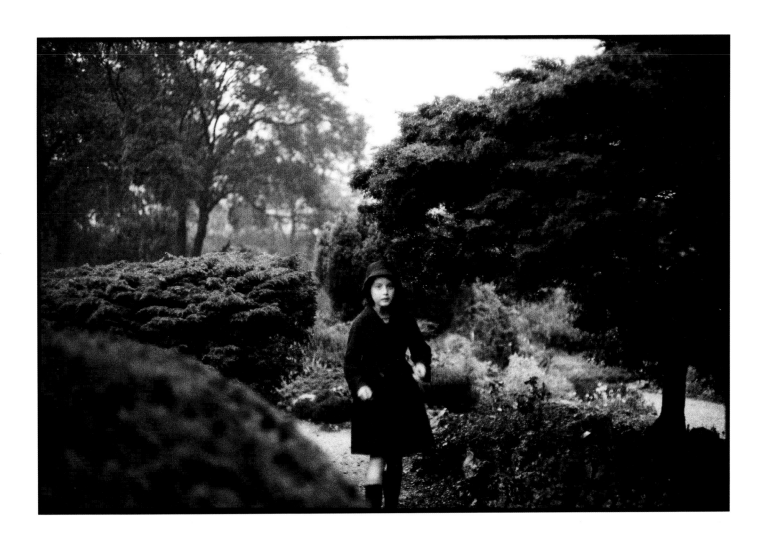

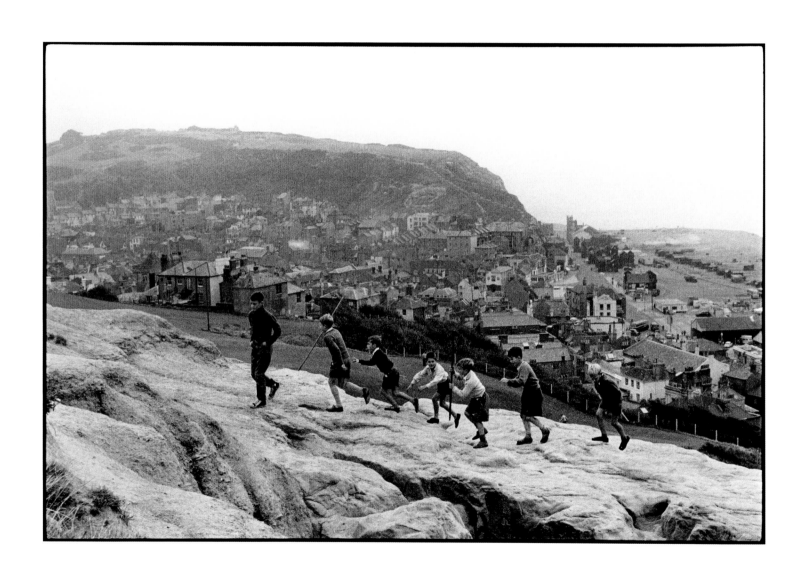

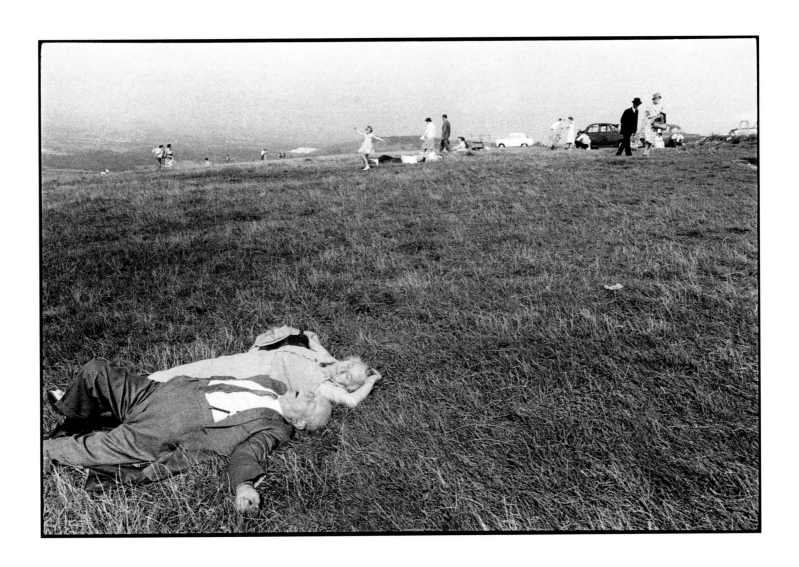

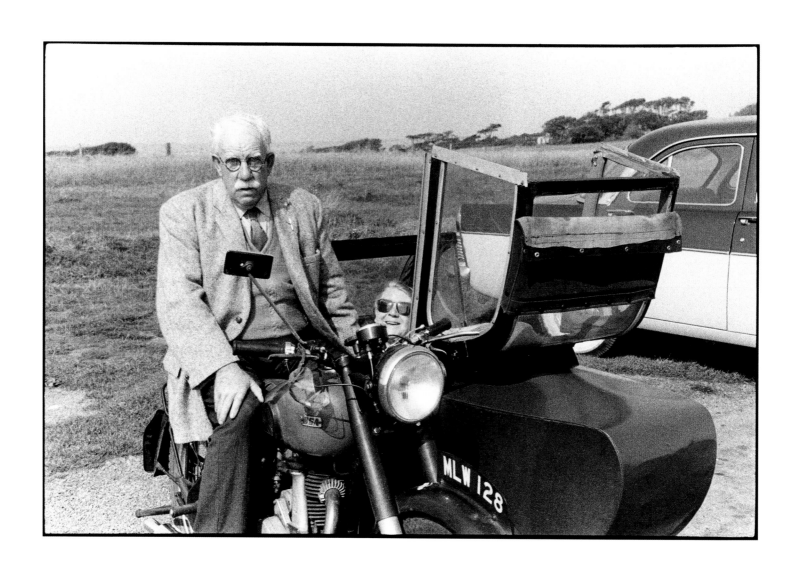

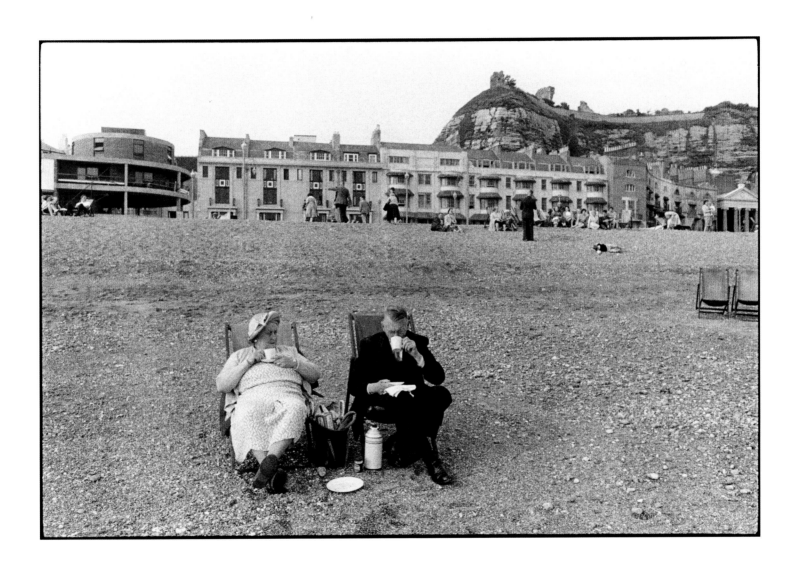

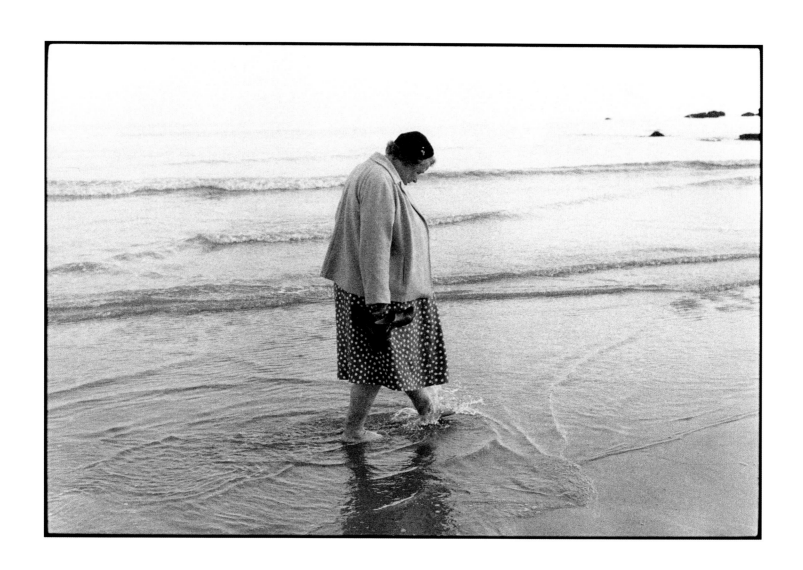

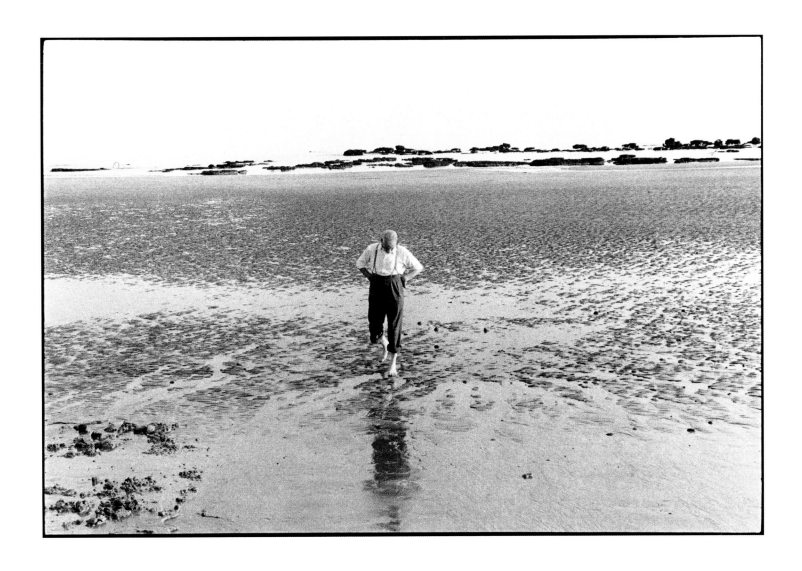

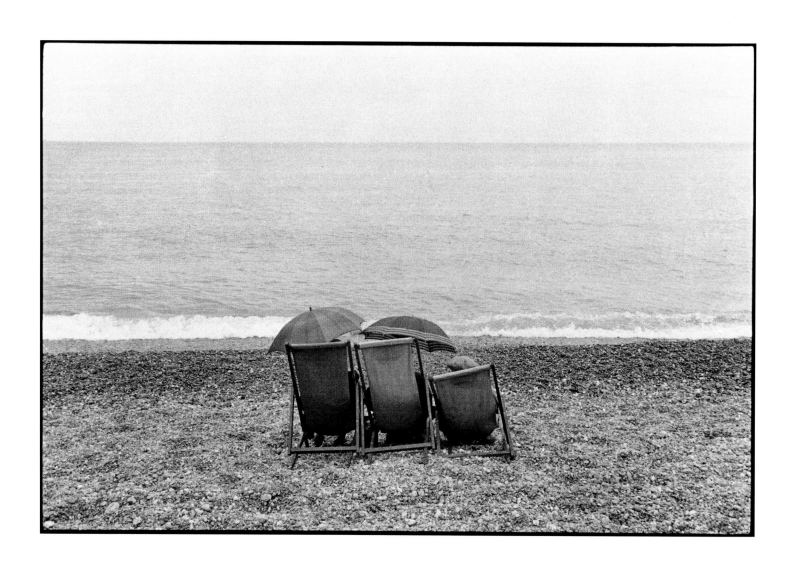

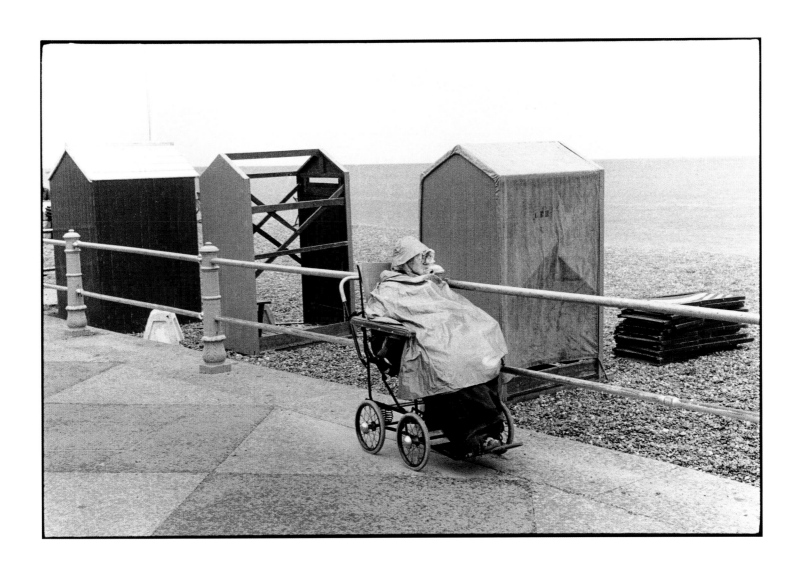

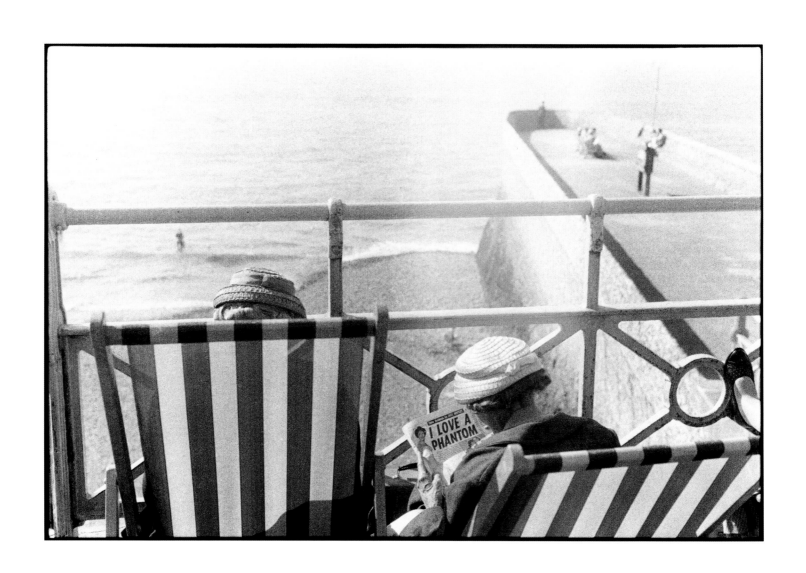

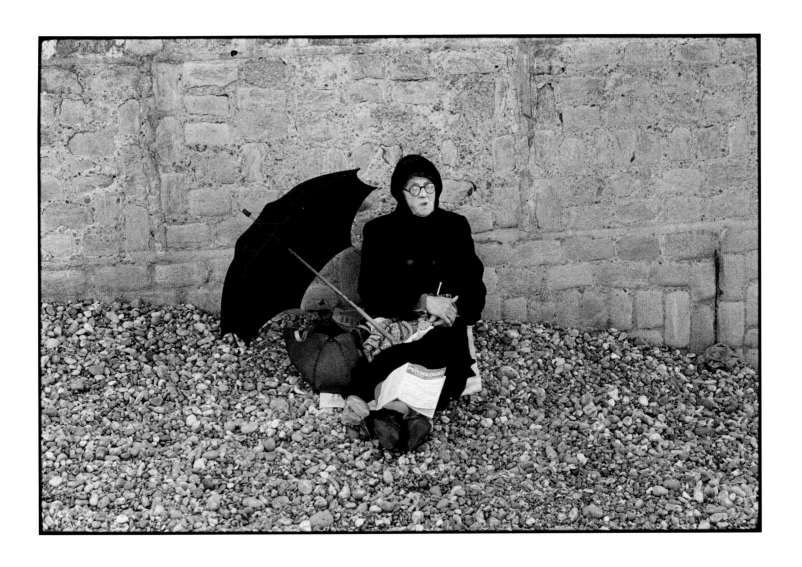

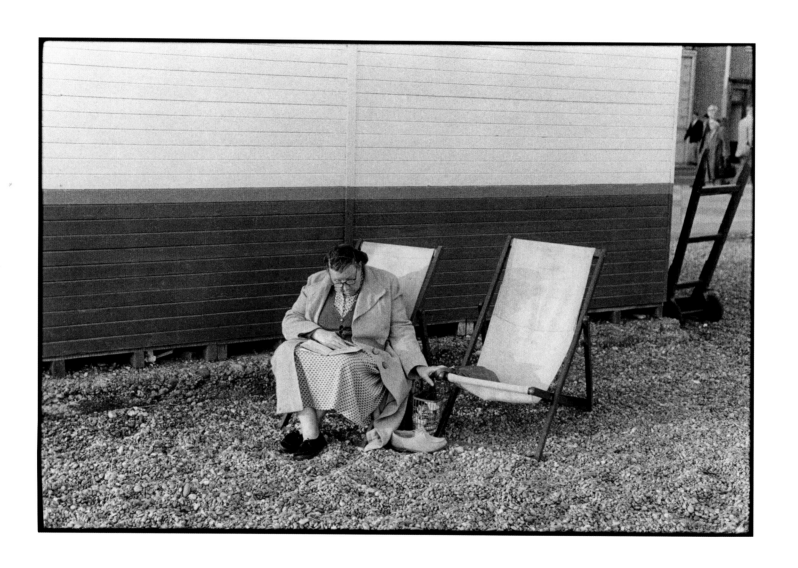

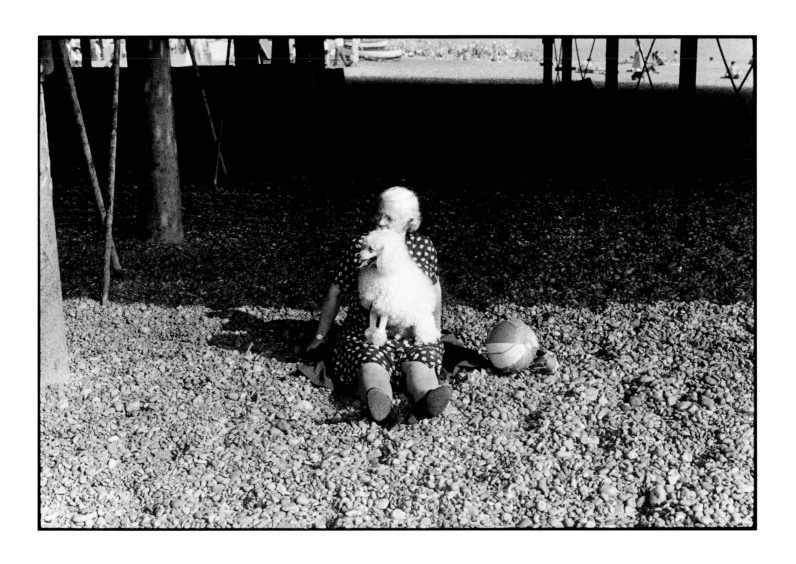

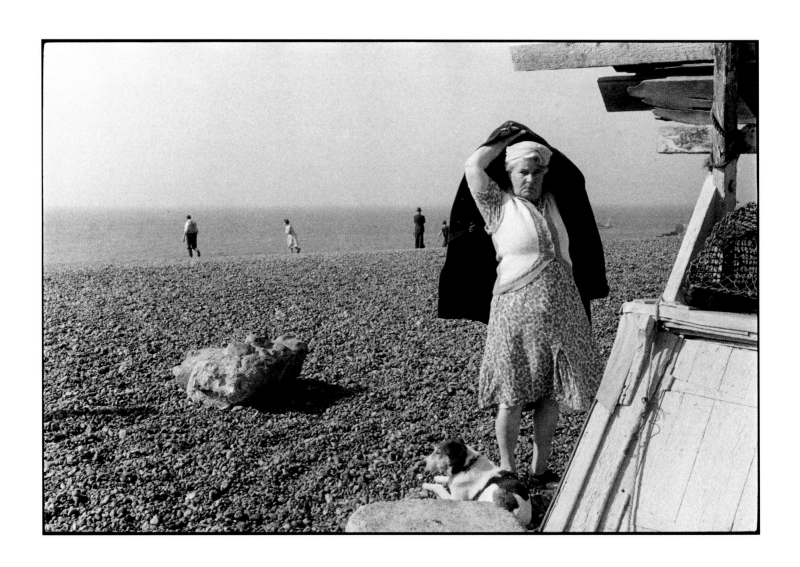

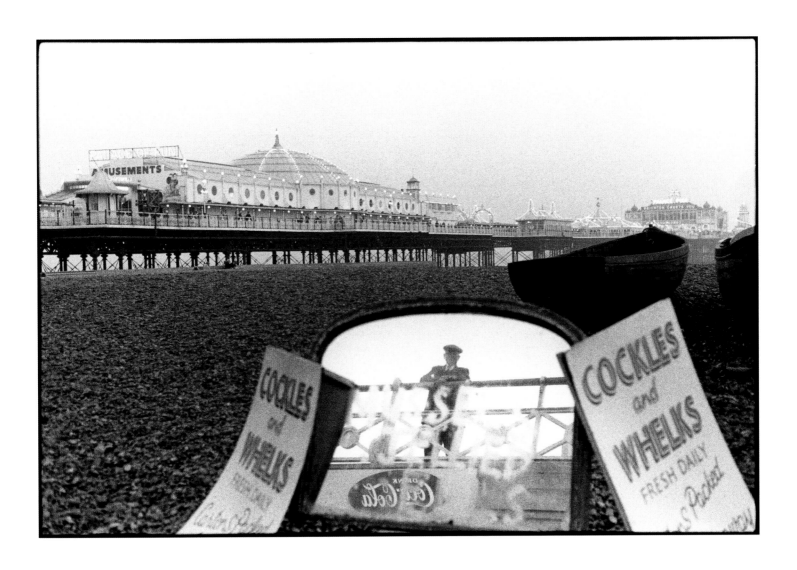

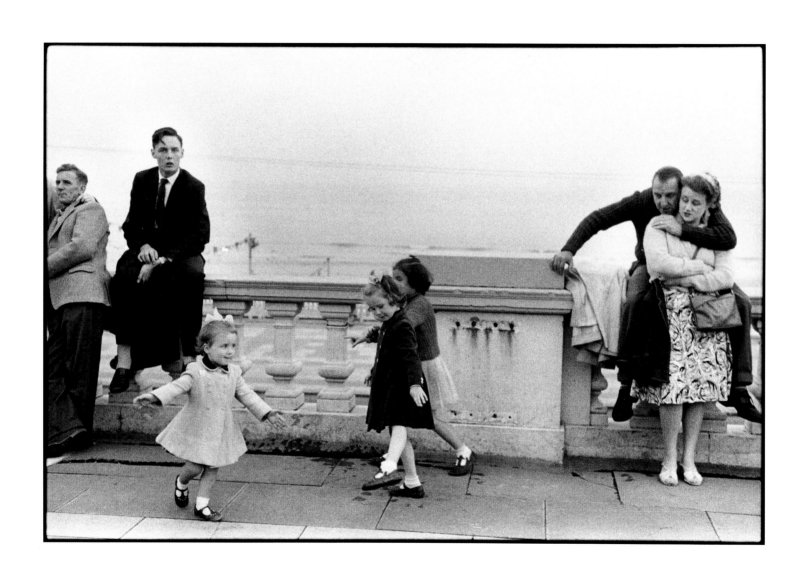

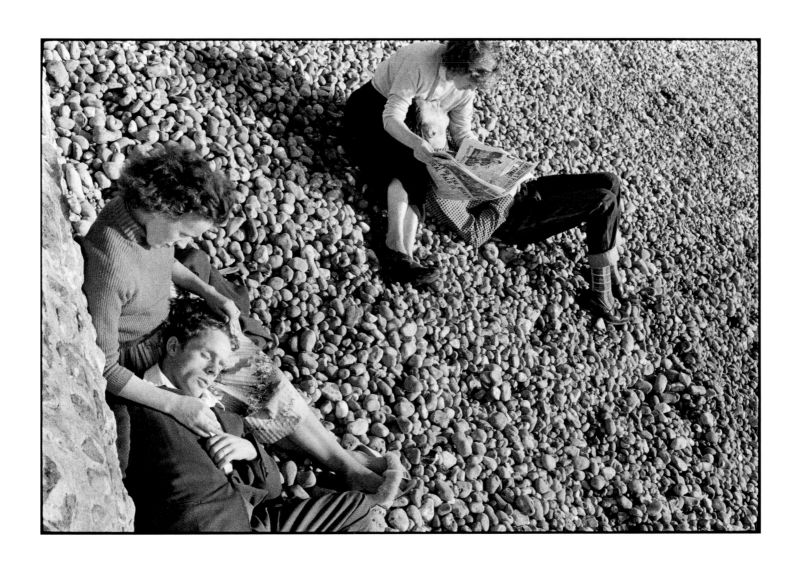

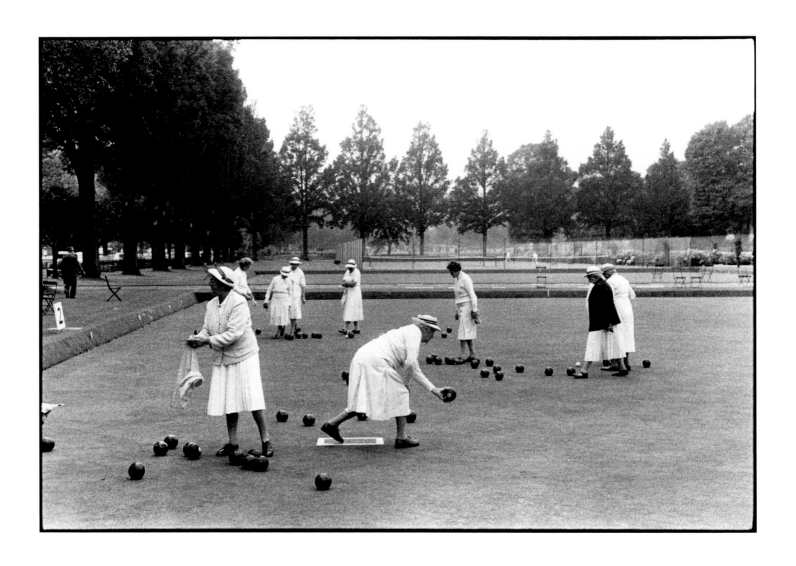

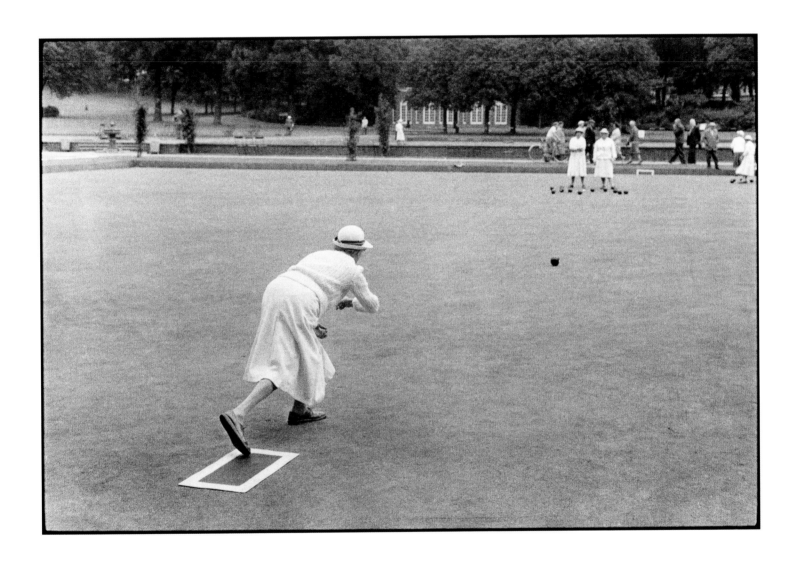

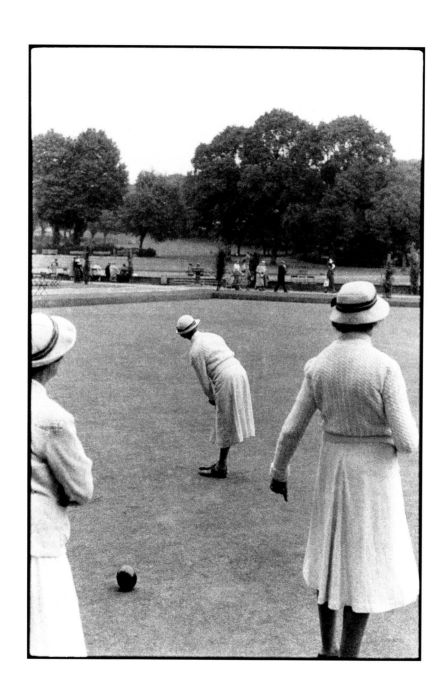

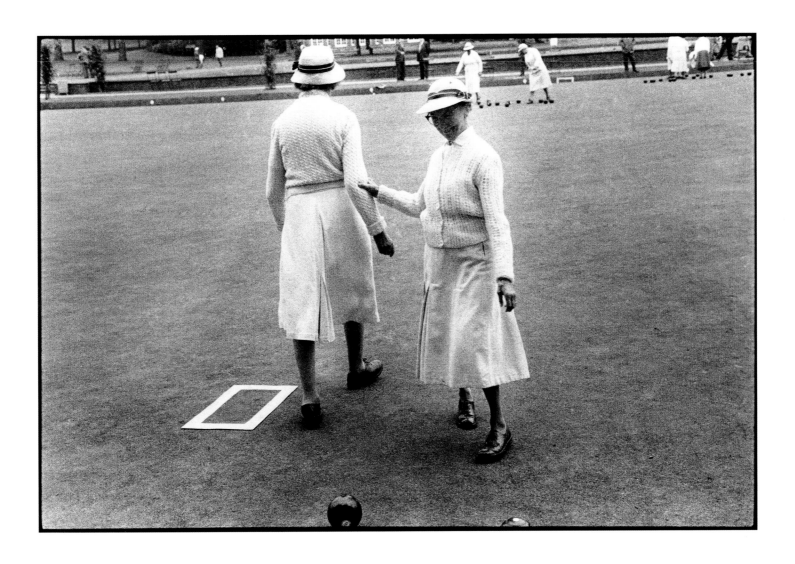

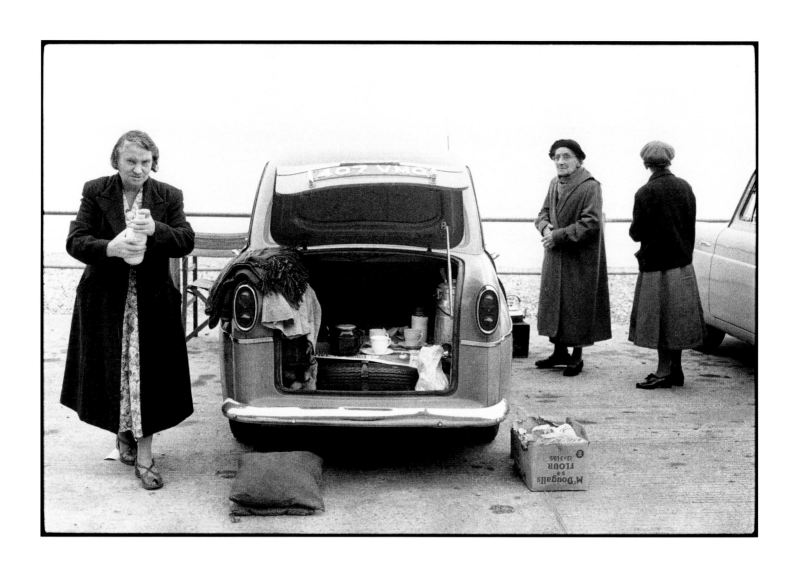

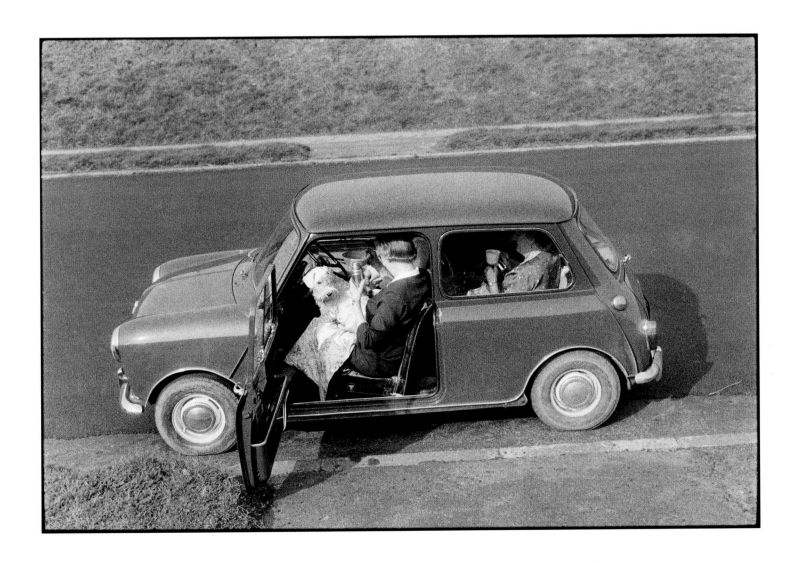

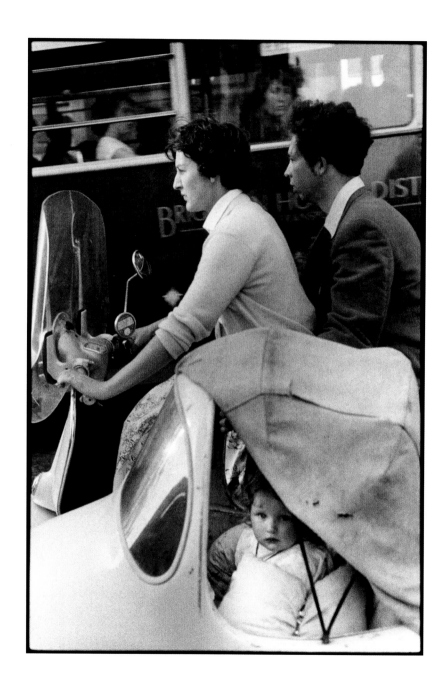

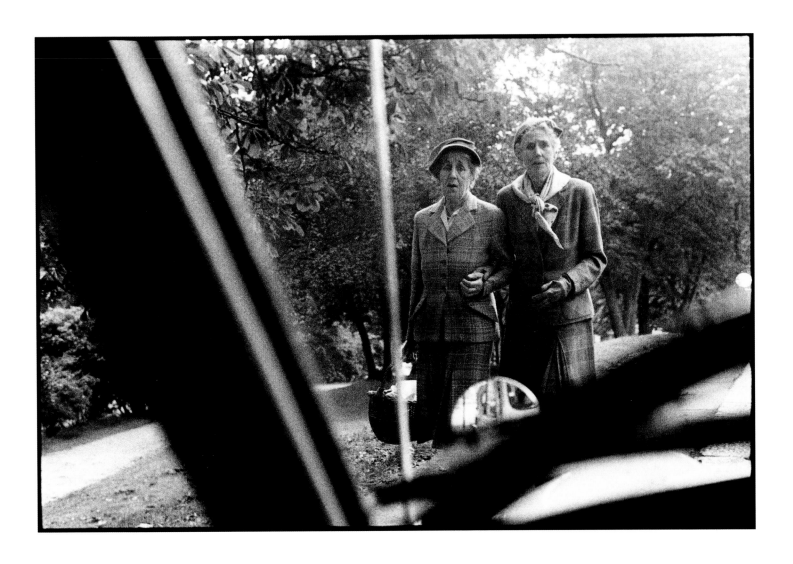

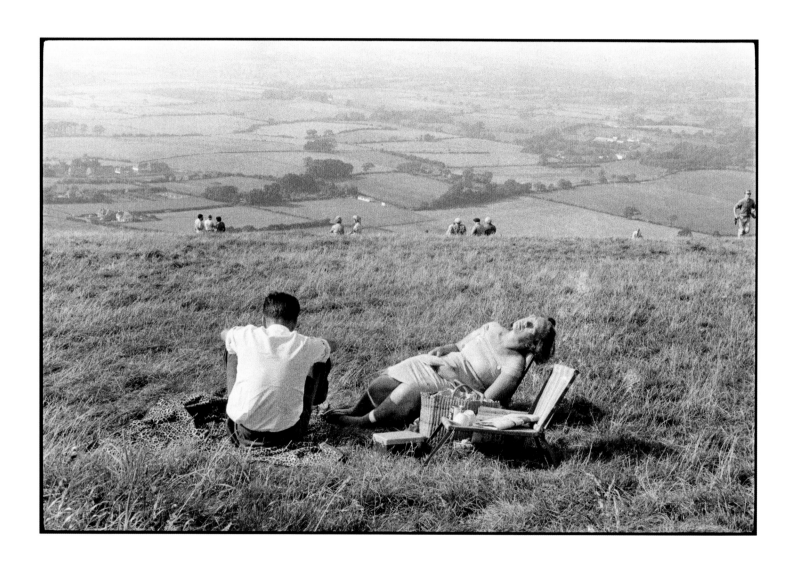

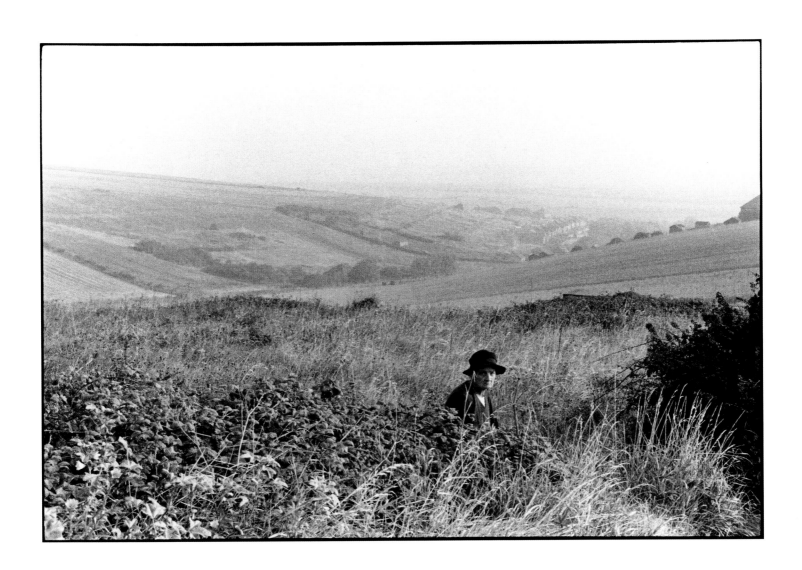

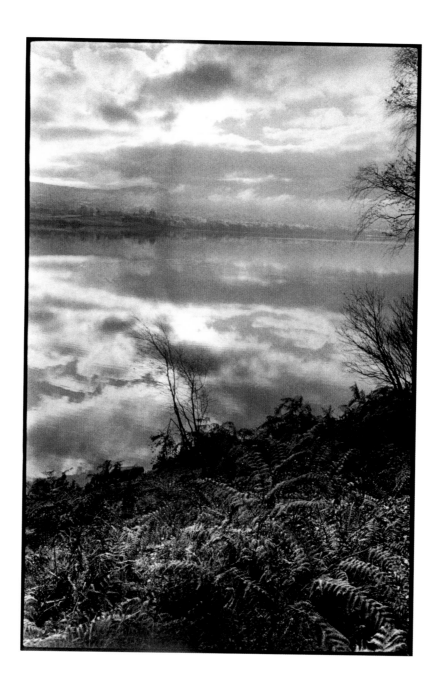

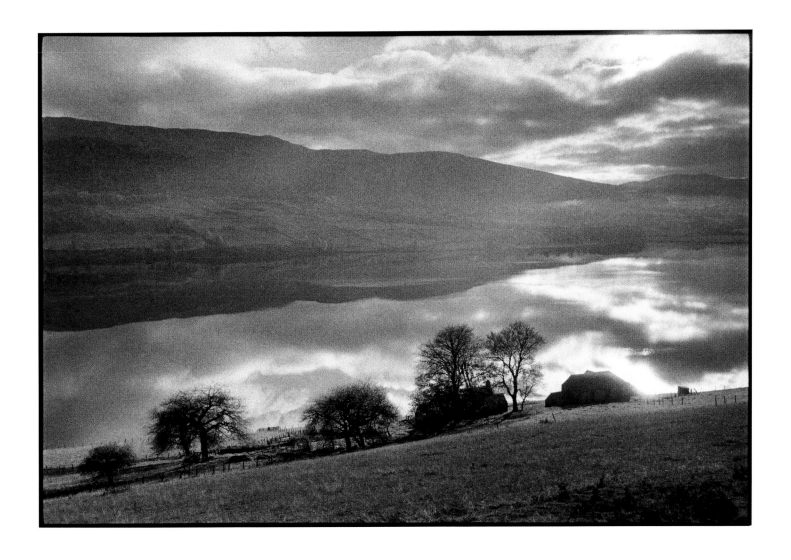

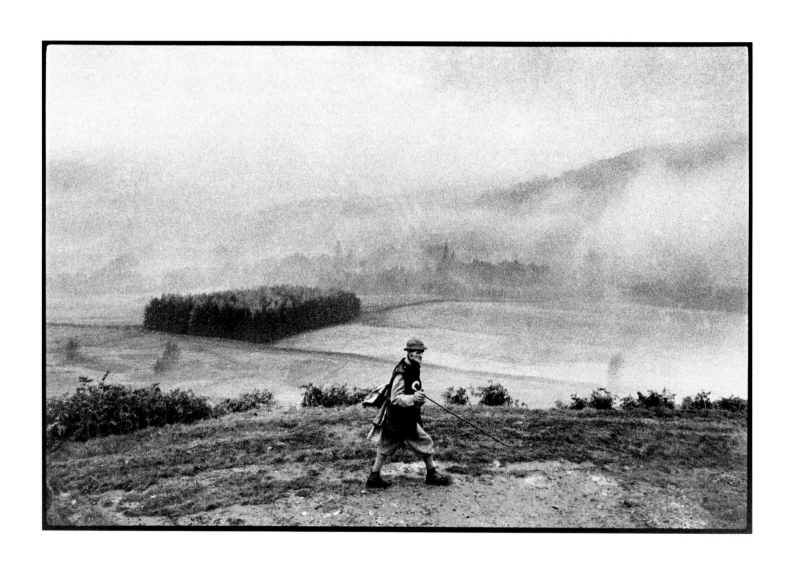

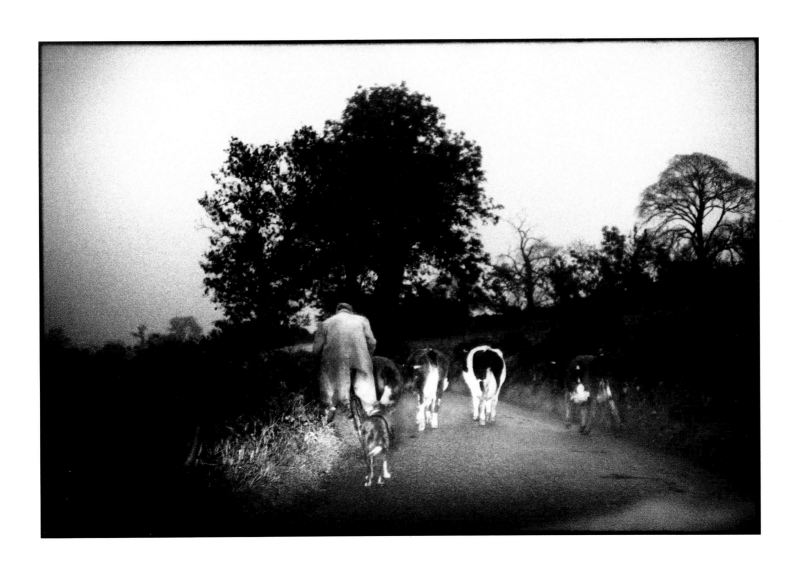

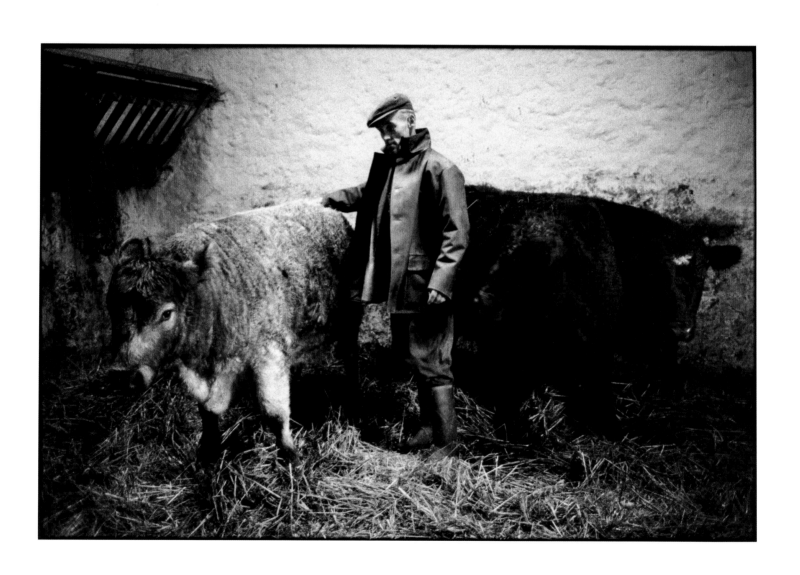

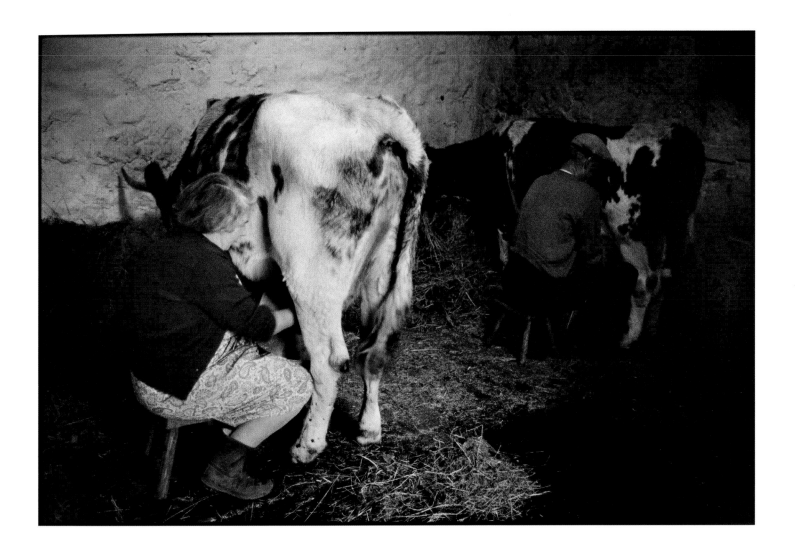

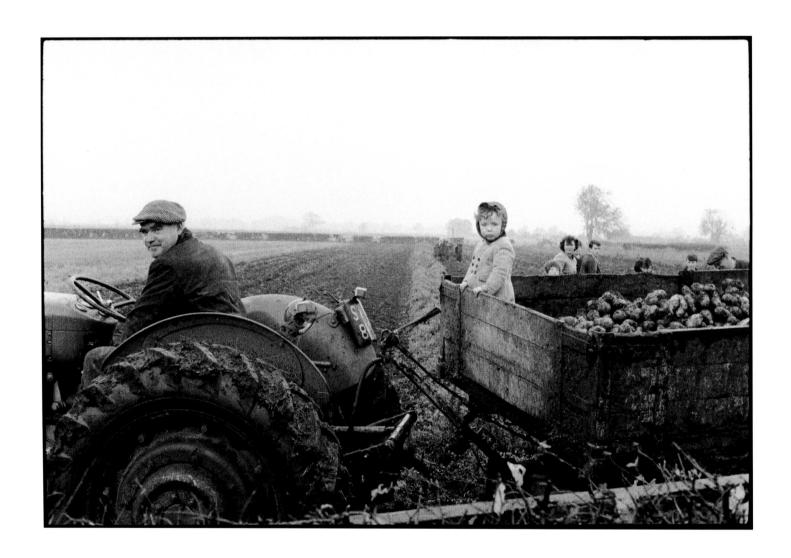

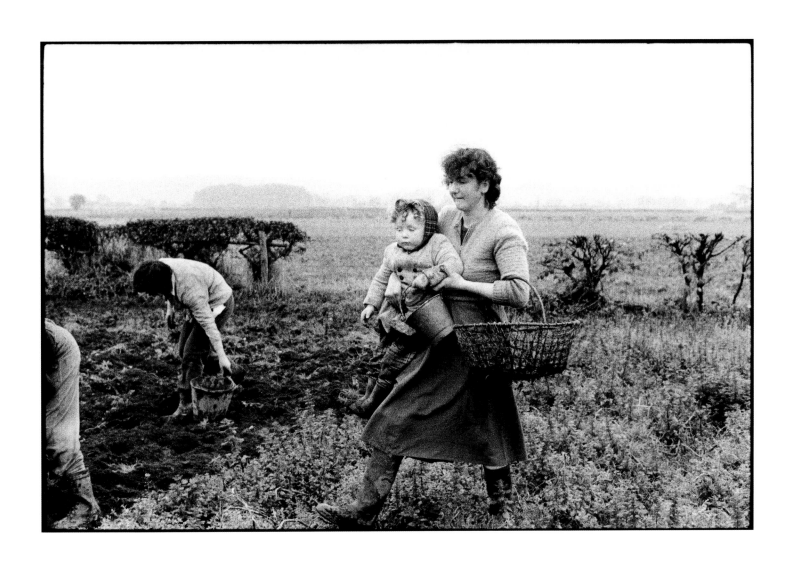

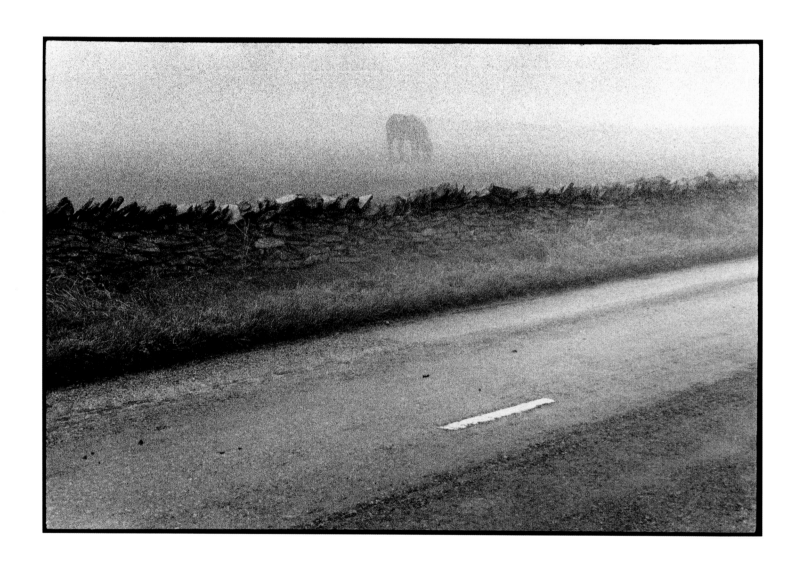

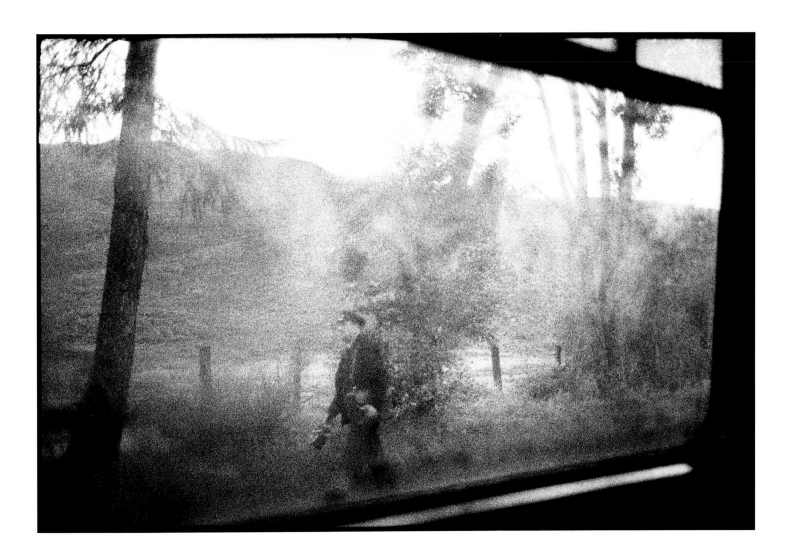

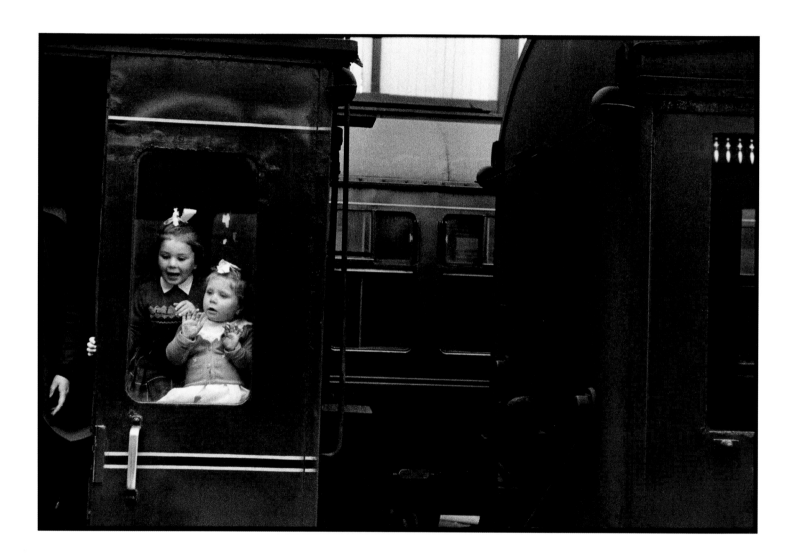

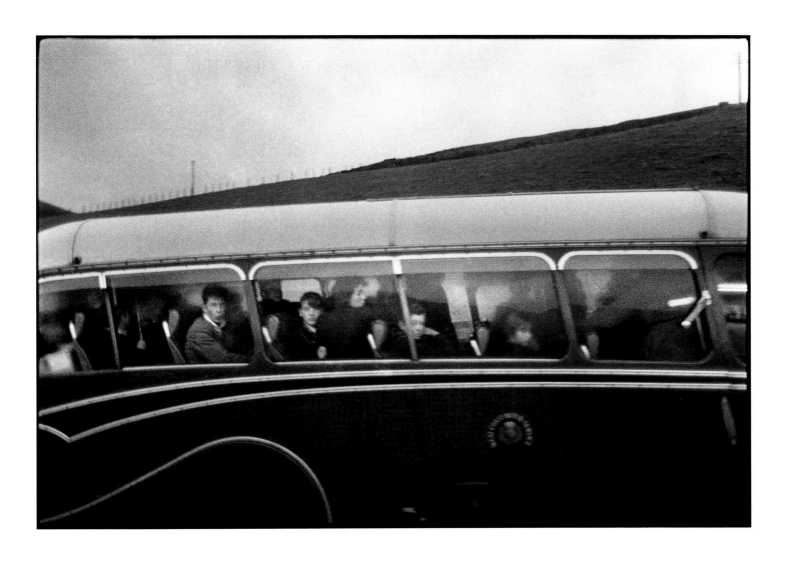

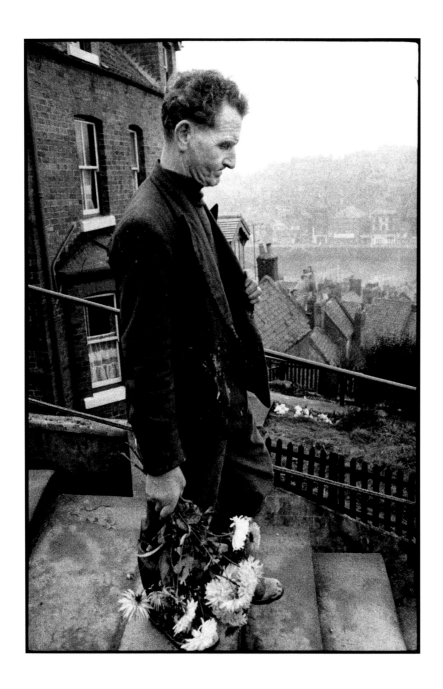

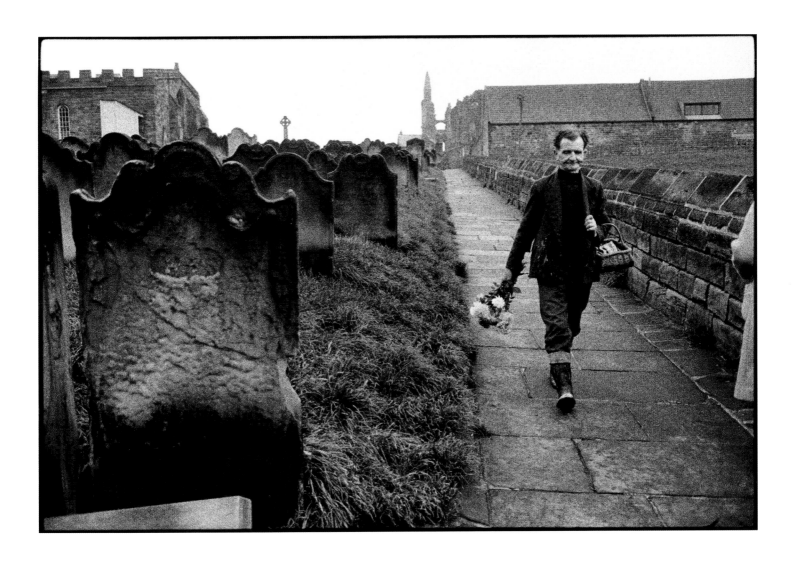

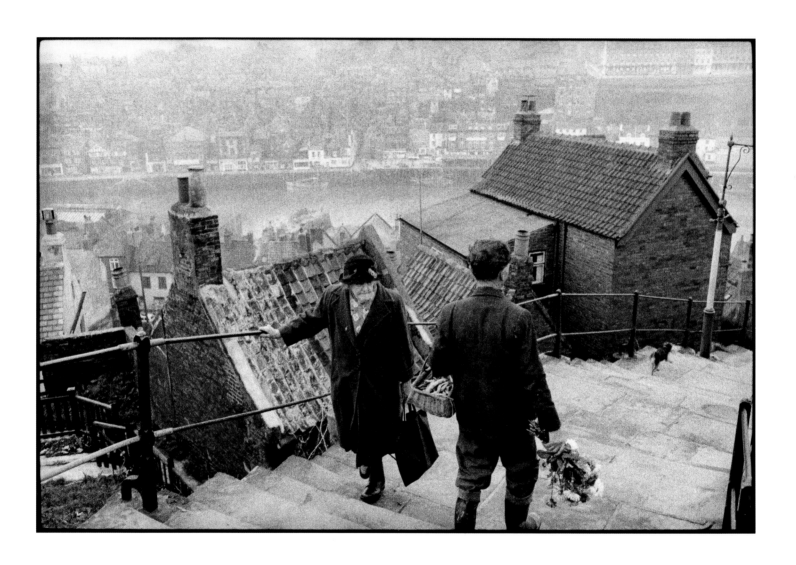

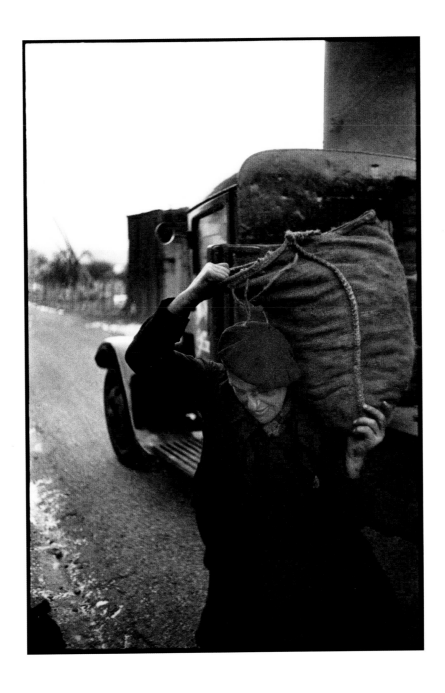

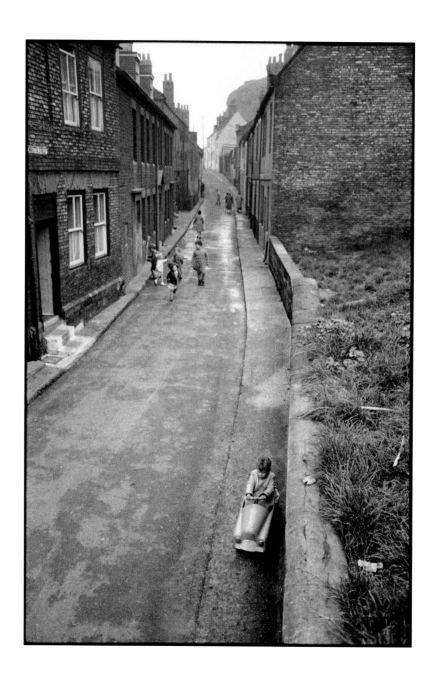

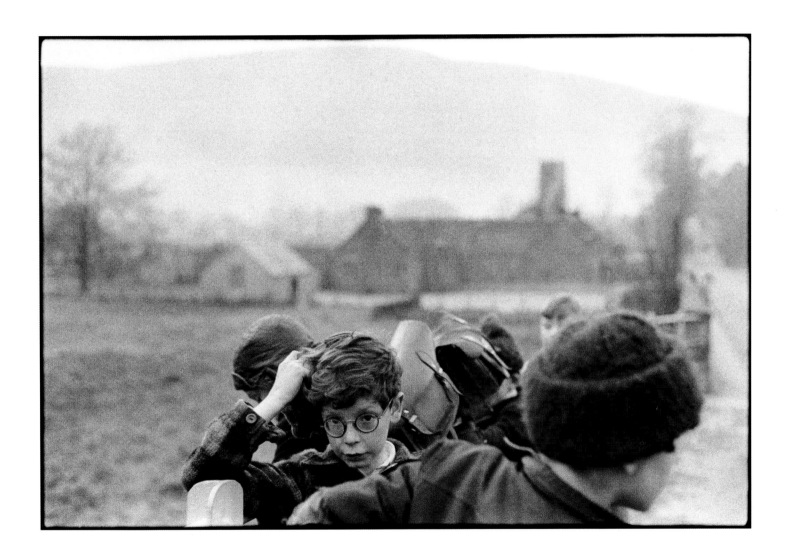

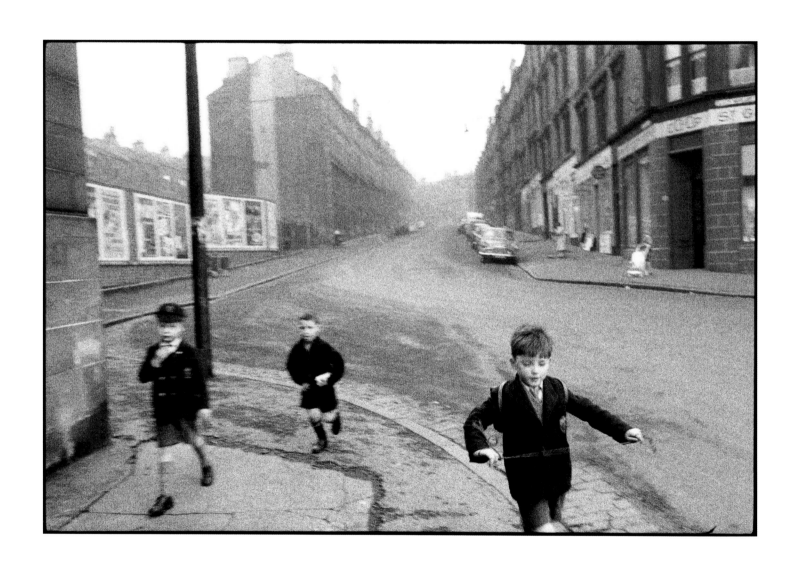

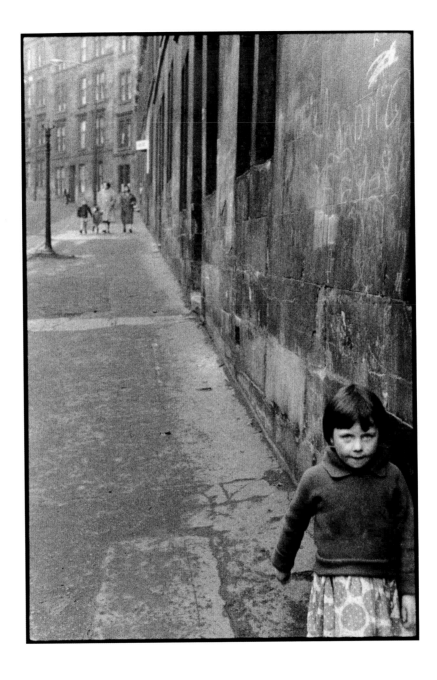

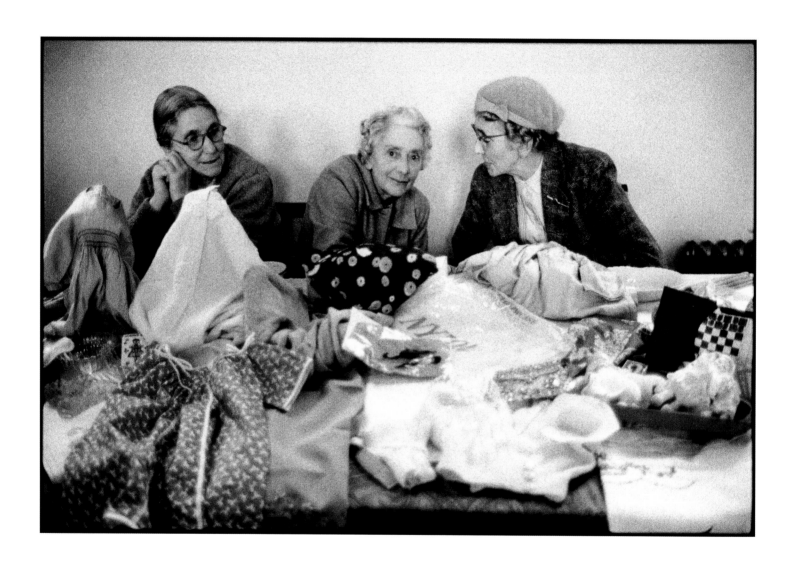

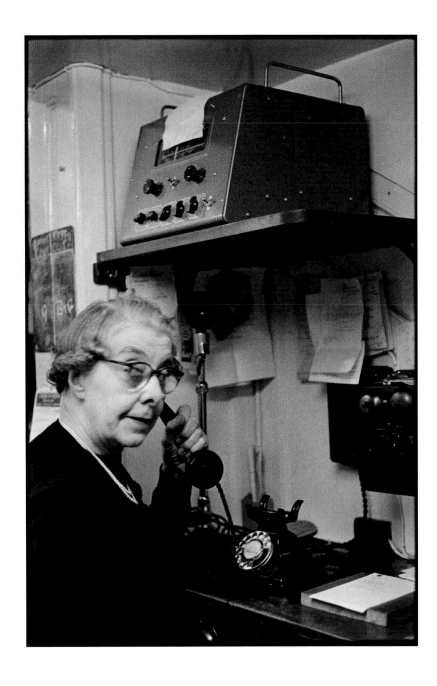

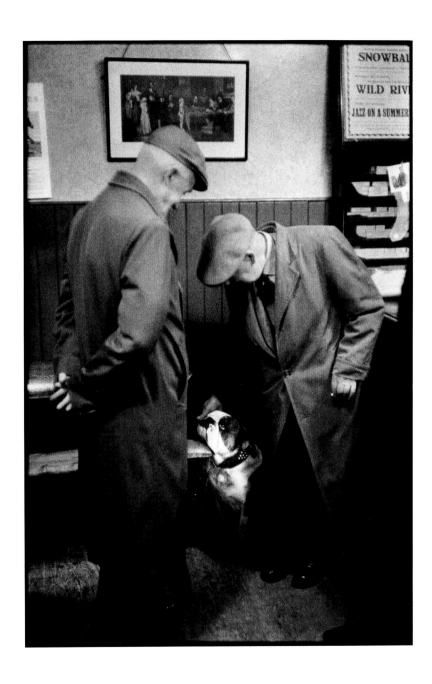

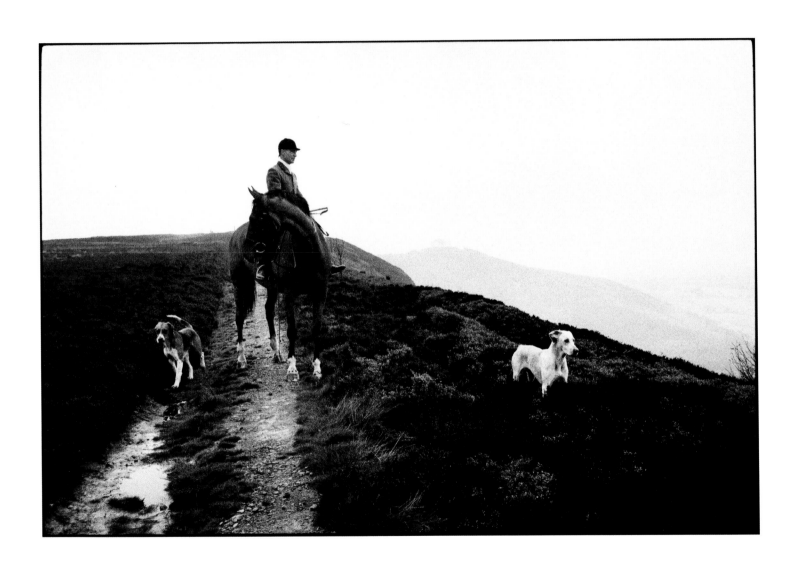

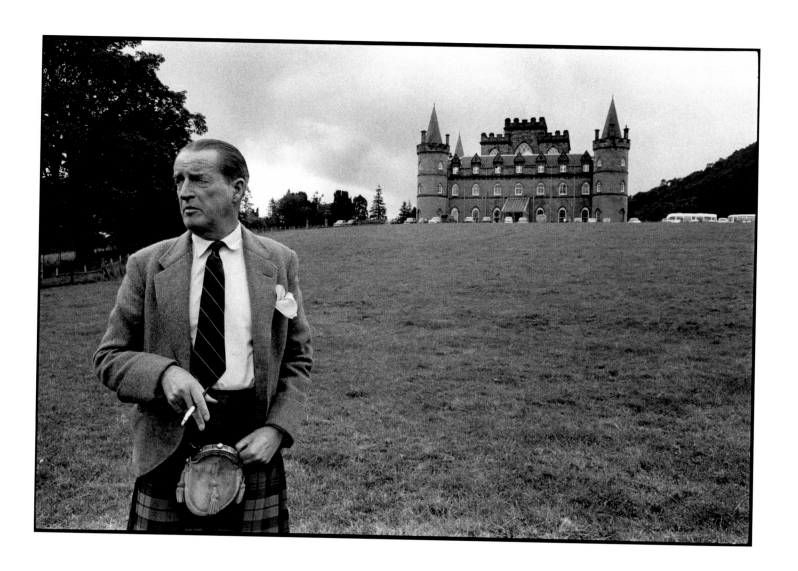

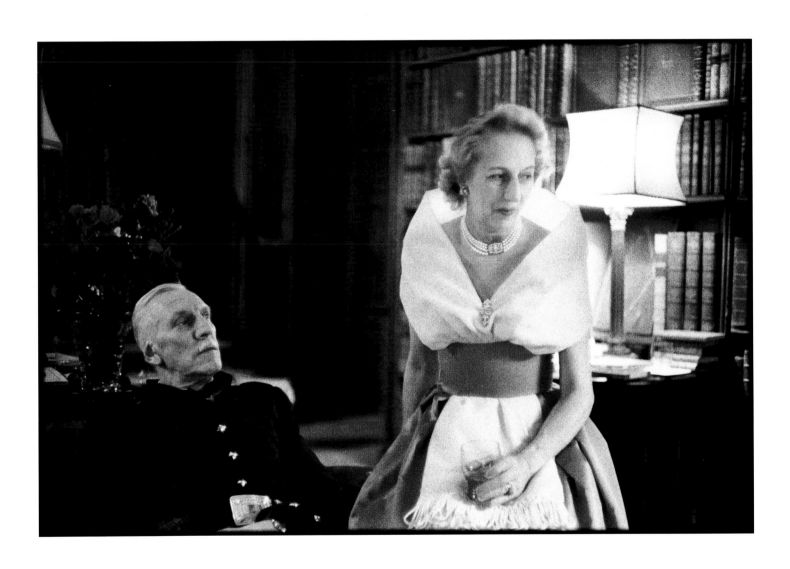

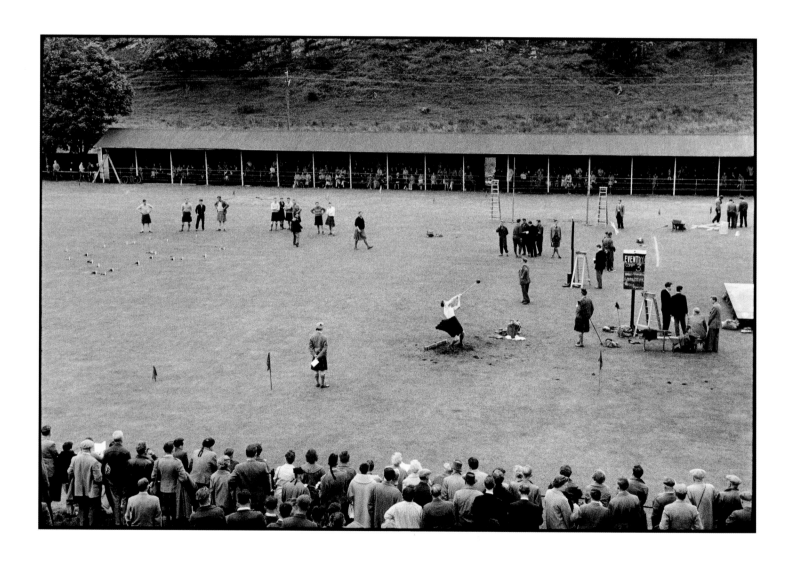

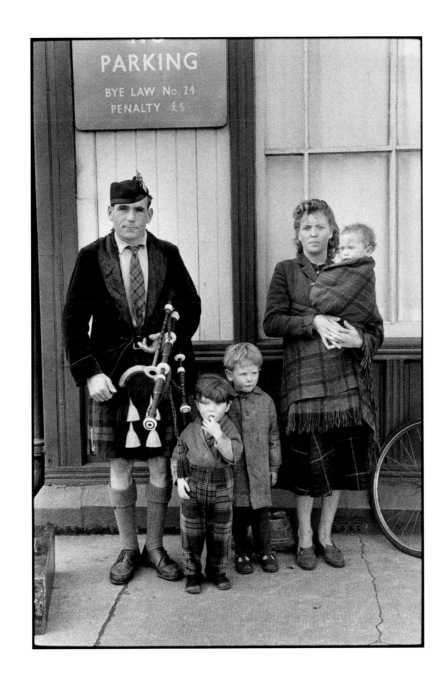

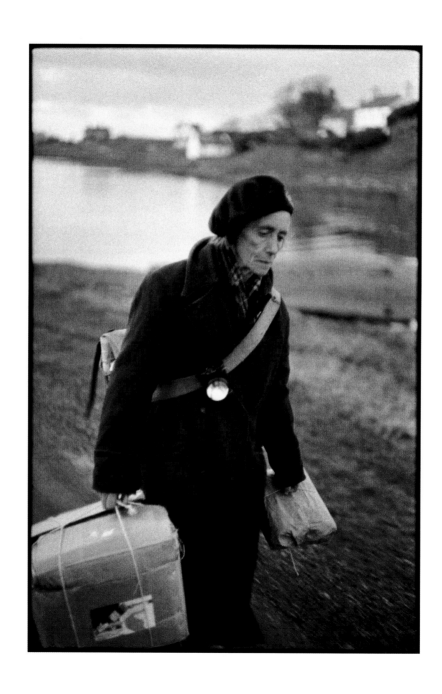

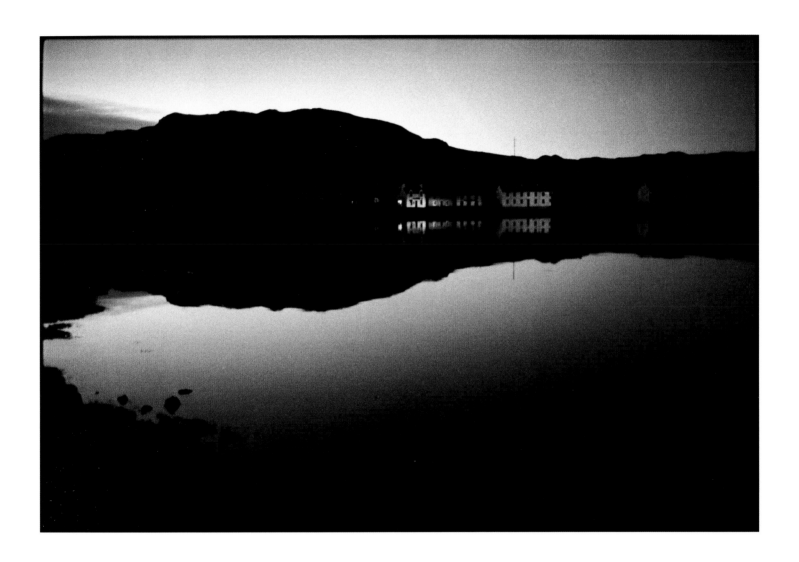

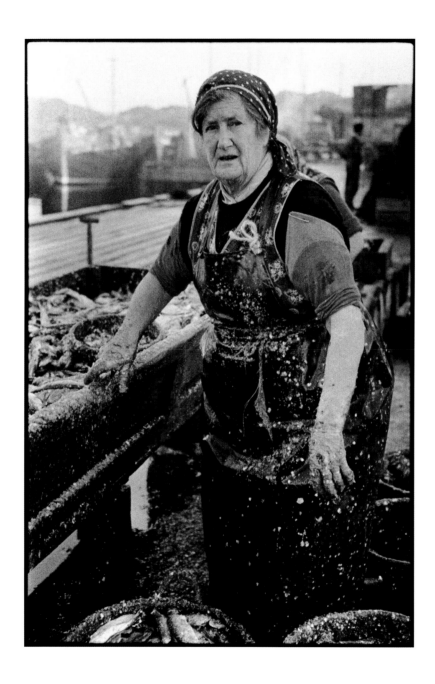

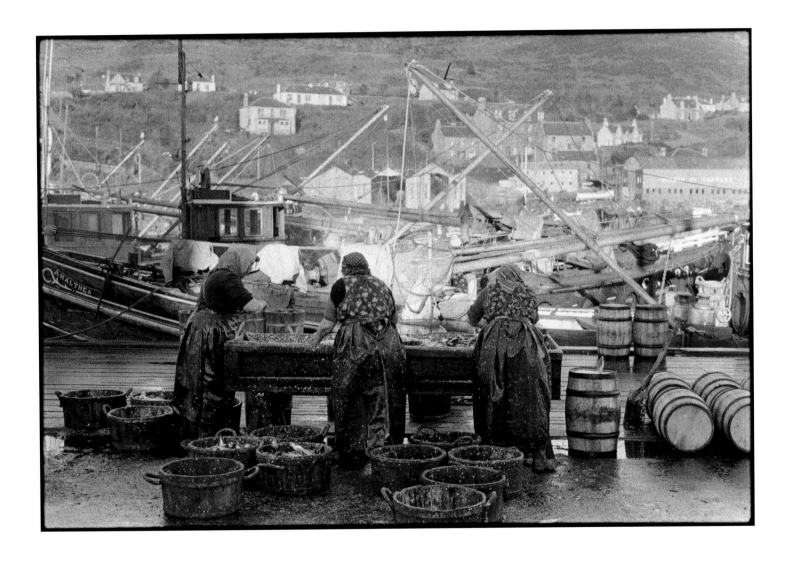

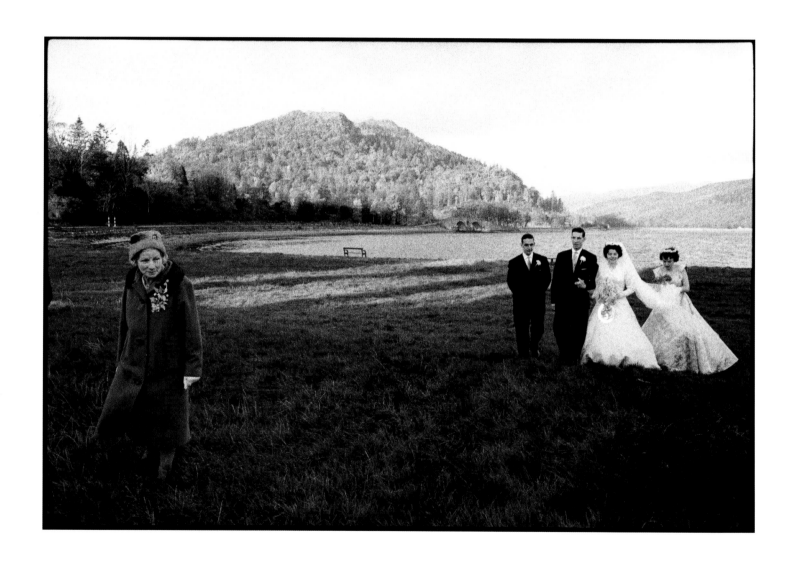

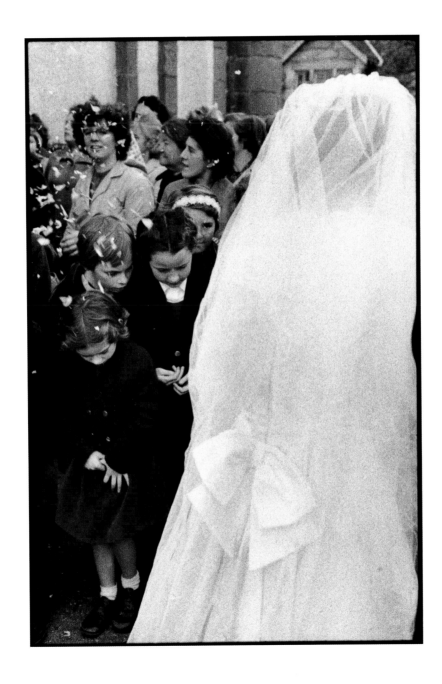

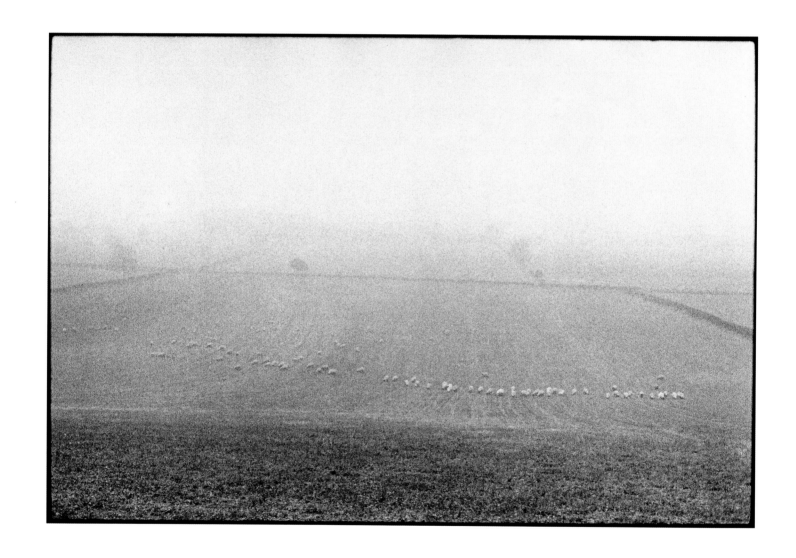

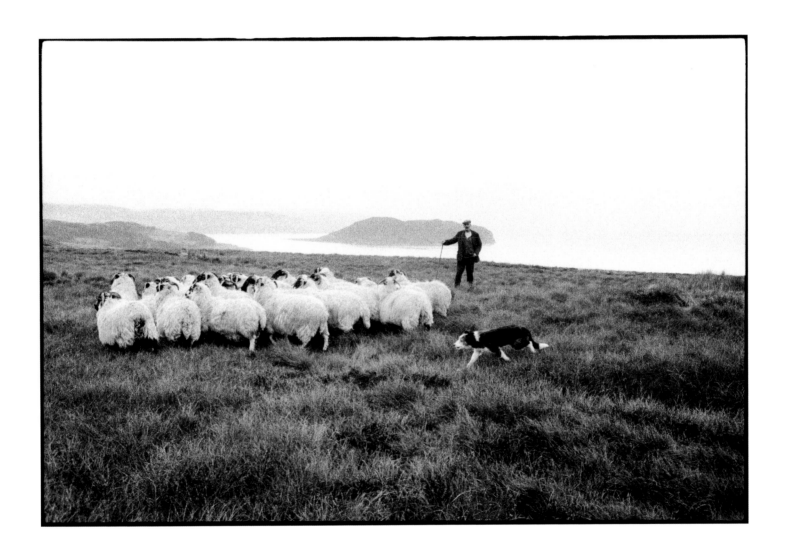

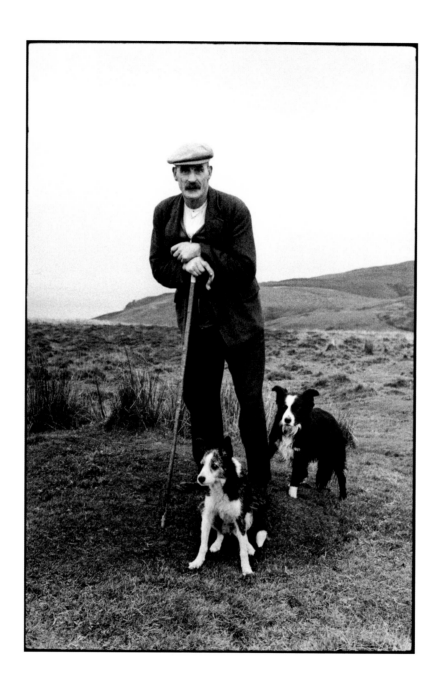

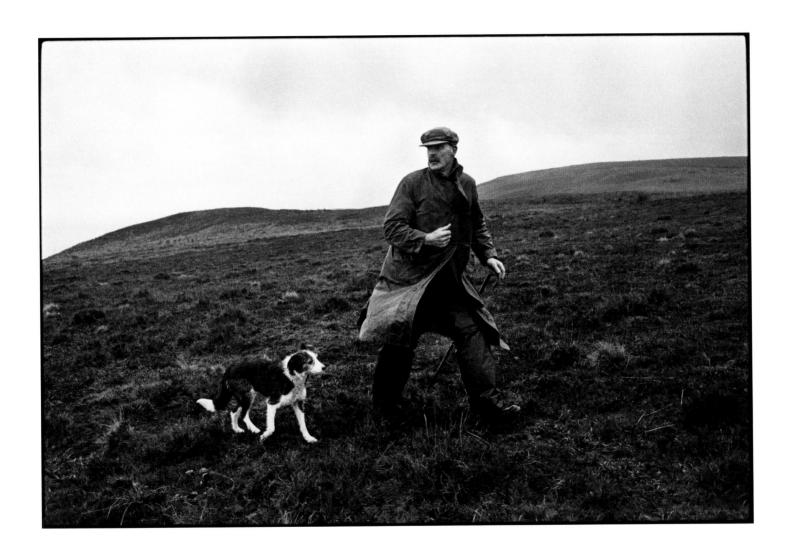

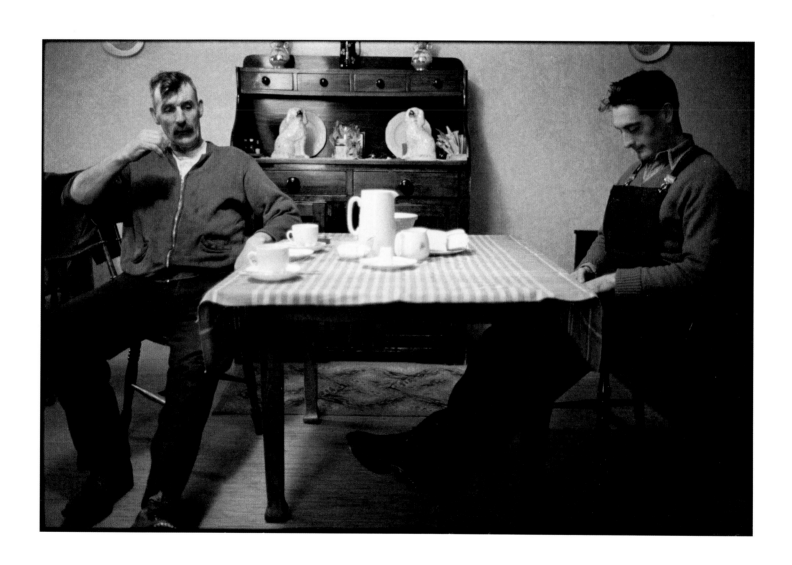

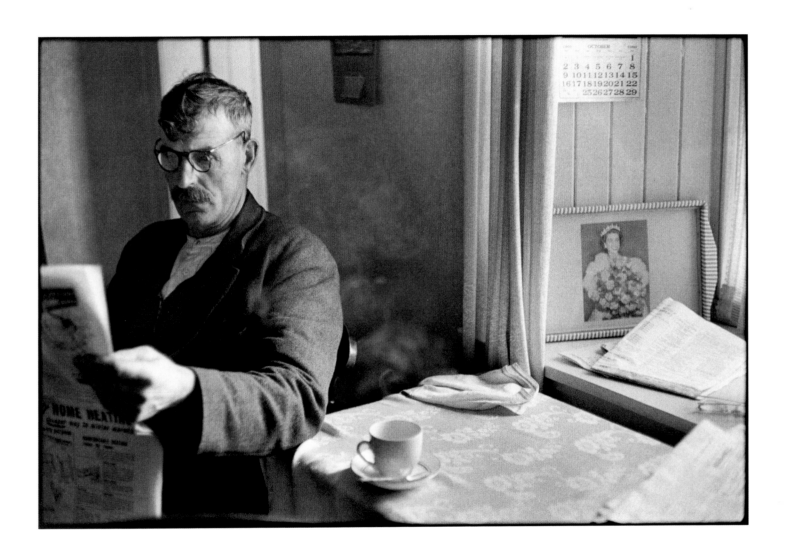

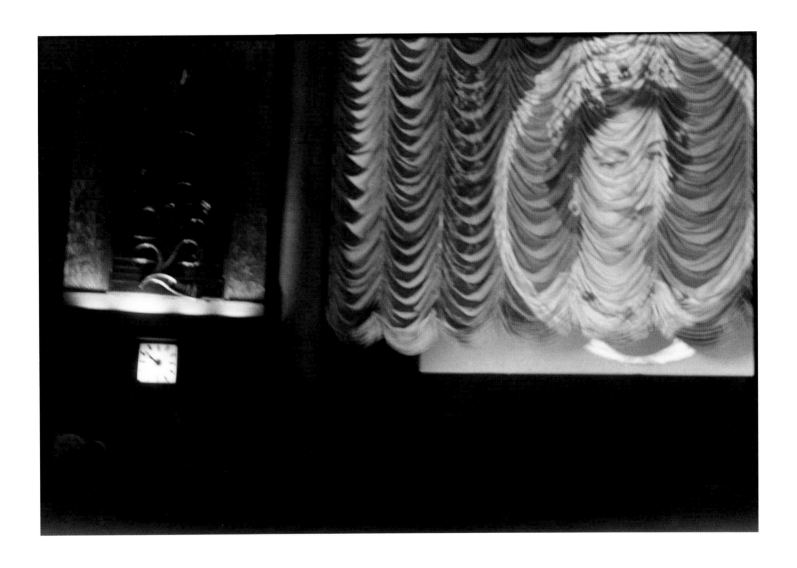

Before the moment: looking back at 1960

Mark Haworth-Booth

I have been looking at the photographs in this book for over two months and they have had a strange effect on me. Because of them, I've been staring at strangers in the street, as well as on buses and trains. I try, as I examine their faces and clothes, to imagine how they (or their photos) would look to someone in 45 years time. Would they look late 20th century or early 21st century? Would they look like that person's idea of 2005, or would they see the faces – our faces – as belonging to an earlier or later time?

I was born in 1944 and grew up in southern England. I remember the old men of our village in black waistcoats, white 'grand-dad shirts' – fastened at the top with a stud. They had few teeth, sparse hair and National Health Service spectacles, but their dignified, weathered faces seemed to have been styled, once and for all, in the 1910s or 20s. They were archaic and immemorial, like the oaks around the cricket field, and belonged to the era of farthings – the small copper coins, decorated with a wren, that ceased to be legal tender in Britain at the end of 1960.

I saw similar faces when I started working at the Victoria and Albert Museum in London in 1970. The senior warders who handed us our keys each morning seemed to me to have First World War faces and moustaches. This was impossible. Someone who was 18 in 1918 would have retired in 1965. However, there was still something in the style of the face and hair – for example, a grizzled centre-parting reminiscent of George V – that evoked other and epic times. The faces were fashioned long ago in ways that are beyond the superficialities we associate with the word fashion.

I look at these photographs and many of them startle me. I was around in 1960 – at school in Brighton, where several of these pictures were taken, and I showed off my pointed winkle-picker shoes in London a few times a year. My memory of 1960 is nothing like this. Just as £99 pounds seems much less than £100, so 1960 sounds much more recent than 1959. Saying 'The Fifties' conjures up a very different image from 'The Sixties'. The Fifties are black and white or middling grey, the Sixties are in colour. The Fifties are Pop, the Sixties Rock.

The year 1960 seems to be an unusually imprecise hinge between two distinct decades. The evidence of these photographs suggests that what we think of as the Fifties went on well into the Sixties, just as the Sixties themselves only expired with the world oil crisis of 1973. Philip Larkin (born 1922) placed the commencement of the decade that Swung with these much loved and often quoted lines from his poem 'Annus Mirabilis': 'Sexual intercourse began / In nineteen sixty-three / (Which was rather late for me) / Between the end of the *Chatterley* ban and the Beatles' first L.P.'

As a sixth-former in 1960, I followed with prurient relish the proceedings of the trial which deliberated over the alleged obscenity of D.H. Lawrence's novel *Lady Chatterley's Lover*. David Sandbrook discusses the event in *Never Had It So Good: A History of Britain from Suez to the Beatles* (2005): 'For many observers, the *Chatterley* trial caught the mood of a society on the brink of a new era of hedonism, liberation and excitement, precisely those values that are most often associated with "the sixties".' He quotes Christopher Booker, who wrote in 1969 of 'a new spirit of modernity and adventure'.

These photographs show us a Britain that belies this image of the

period. Davidson writes in his 'Time Line' about aspects of English and Scottish life that particularly struck him. First, the bomb damage still visible in London reminded him of radio broadcasts he heard and photographs he saw in *Life* magazine as a child during the Second World War: 'It gave me a sense of how the British survived and made the best of things'. Soft baby-boomers like myself need to remember that many faces in these pages are marked by the experience of living through two world wars.

In the City of London Davidson noticed two men in top hats walking briskly past the Bank of England and thought to himself 'how distant from my own experience was this need for a formal dress code that sets one apart from others in the class system'. His photographs are observant of the social clues displayed by clothing, hair-styles, hats and gestures. I asked the fashion historian Valerie Mendes, formerly Keeper of Textiles and Dress at the V&A, to look at these photographs with me. The knowledge Valerie generously shared with me has been invaluable in writing this essay. I have also had the benefit of discussing the photographs with John Hillelson, then Magnum's agent in London, who set up the commission with *The Queen* magazine which brought Davidson to Britain for two months in the autumn of 1960. I also spoke with the photographer Tessa Traeger, who worked at *The Queen* – at the age of 20 – in 1958-59, and the Magnum photographer David Hurn, who showed Davidson round London and introduced him to friends and colleagues. Their perceptions, so kindly volunteered, are used most gratefully here. I was also fortunate enough to correspond with Davidson himself by email.

John Hillelson was able to tell me about the major role played by *The Queen* in British cultural life in the late 1950s and early 1960s. It had been a sleepy magazine for the genteel until it was bought by Jocelyn Stevens, a 25 year-old Cambridge graduate, in 1957. Stevens

was part of a publishing dynasty headed by Edward Hulton, proprietor of three key magazines – *Weekly Illustrated*, *Picture Post* and *Lilliput* (which were all defunct or dying by 1957). Stevens brought to the magazine not only his own publishing *nous* but his Cambridge friend Mark Boxer as art director. Colleagues included Beatrix Miller as editor and Drusilla Beyfus as associate editor. All were to enjoy illustrious careers in British journalism. Boxer left in autumn 1961 to launch the *Sunday Times Colour Section* (later *Magazine*), while Miller and Beyfus departed to run *Vogue* in its halcyon days. However, in the years around 1960, *The Queen* was supreme. Major picture stories published there included Henri Cartier-Bresson's 'Red China', spread over 80 pages in four issues in 1959. *The Queen* commissioned Cartier-Bresson to photograph Queen Charlotte's Ball the same year. In 1961 it published the legendary photo-essay 'Monsoon' by Brian Brake.

Tessa Traeger remembers that when she worked at *The Queen* as assistant to its chief photographer John Hedgecoe, the atmosphere was simultaneously exciting and stultifying. On the one hand Jocelyn Stevens and Mark Boxer could hardly have been more dashing, self-confident and central to London's social and cultural life. However, on the other hand, the offices were full of snobby ex-debutantes in cashmere twin-sets and real pearls. She recalls how, as the Sixties took off, the ex-debs suddenly – almost overnight – started to shop at Biba, wear mini-skirts and want to meet boys from bands and go to art school.

Looking back at *The Queen* (which changed its name to *Queen* in January 1962) in his introduction to his book *The Sixties in Queen* (1987) Nicholas Coleridge described it as playing a major role in inventing 'the combination of deeply serious and aggressively ephemeral articles that still provide a structure not only of *Harper's and Queen* today, but for dozens of titles from Manhattan to Tokyo'.

He credited Stevens with establishing the tradition of 'tough journalism on shiny paper'. The visual liveliness of the magazine stemmed from Boxer, who introduced experimental typography, witty cartooning and the consistent use of distinguished photography.

During 1960 the magazine saluted many cultural events which seemed important then – and still do. 1960 brought *The Caretaker* by Harold Pinter and *Rhinoceros* by Eugene Ionesco at the Royal Court Theatre and *Billy Liar* by Keith Waterhouse at the Cambridge Theatre; *Saturday Night and Sunday Morning* by Clayton, *The Apartment* by Wilder, *L'Avventura* by Antonioni and *La Dolce Vita* by Fellini; a 'Beat, Square and Cool' season at the National Film Theatre featuring Robert Frank's *Pull My Daisy*; a landmark exhibition of Picasso at the Tate; the satirical review *Beyond the Fringe* was launched at the Edinburgh Festival.

John Hillelson had often worked with Stevens, especially on major features by Henri Cartier-Bresson. Cornell Capa of Magnum in New York had been a staff photographer for *Life* working out of their London office in the early 1950s. Capa and Hillelson set up Davidson's commission with *The Queen* and arranged for the magazine to publish two of his photo-essays in the autumn of 1960. Under the title 'Columbus – should he have gone so far?', the issue for 12 October used Davidson's photographs of the Statue of Liberty seen from unusual vantage points around New York to open a major debate about America.

I vividly remember the anxiety felt about American influence at that time. On the one hand many Britons resented their country being over-taken as Top Nation by the United States. On the other hand America represented innovation and excitement in all the things that really mattered, like cars, movies, jazz and rock and roll. American photography looked formidable too – especially when *The Queen* featured William Klein's photographs of Rome (3 May 1960),

Richard Avedon's fashion ('Sphinxology', 8 June 1960), Dennis Stock on jazz (31 August 1960) or Davidson on 'The Teenage Gang' – his famous Brooklyn Gang essay (14 September 1960).

Whereas Davidson portrayed the Statue of Liberty in fresh and dramatic ways, from great distances with telephoto lenses that compress space, 'The Teenage Gang' showed his ability to move very close in on human behaviour. *The Queen* published the most celebrated photograph from the series as large as possible. The photograph captures a young woman gazing into the mirror on a cigarette machine as she pins her hair. As she pulls back and holds down her long hair, her striped shirt pulls forward to reveal her sexy young skin. The youth waiting beside her rolls a pack of cigarettes in his sleeve. In a night scene we see a boy and girl from the gang, perhaps the same two, lying in erotic intimacy on the Coney Island beach. The text with the pictures picked out key words in bold capitals: ADORNMENT, DEFIANCE, BOREDOM, LOVELESS LOVE. It was a bold move by Cornell Capa and John Hillelson to propose that *The Queen* should commission the young American star to photograph the British. Stevens, with the decisiveness Hillelson admired, accepted at once. The shoot was to take place in autumn 1960 and to be published as a major feature the following spring.

The photographs were made with a particular black and white film that Davidson remembers vividly: 'The film I most used was Ilford HP5 (hypersensitive) which means that it was probably pre-fogged (exposed to light or mercury vapours very briefly in the manufacturing process to break the threshold exposure and create a faster film). It had an effective speed of 1000 or 1500 when developed in Ilford's Microphene developer. More than twice that of other films at the time. The lab in London push-processed the film slightly when needed in dim light or at night. But basically this antique film had a character that matched the light permeated in sea fog, opal sky and

the mist and melancholy prevalent in London, the open country side, and along the sea shore. The Ilford film recorded the mid-tones with a poetic British feeling for soft light. It had a beautiful grain pattern'.

In addition to this special kind of film, Davidson used his skills as a reportage photographer. He trained at the famous photography department of the Rochester Institute of Technology in upstate New York. Ralph Hattersley, his teacher, showed the class photographs by Robert Frank. Years later Davidson recalled, in his monograph, *Bruce Davidson Photographs* (1978), 'Frank's grim pictures of Welsh miners coming up from the mines, the elemental mood of a mother nursing her child, and the ominous gloom of the traffic line down an empty street'. He also discovered W. Eugene Smith and, most powerfully of all, Henri Cartier-Bresson.

Davidson was aware of the British photographer, Bill Brandt, through *The Family of Man* exhibition of 1955, which he saw and thought of as akin to the film *Citizen Kane* as a source of pictorial ideas. *The Family of Man* show and book included some of Brandt's eloquent pictures of London and the North East of England. However, it was the dance of life he found in Cartier-Bresson, and perhaps the misty atmosphere typical of Frank – both of them masters of the 35mm Leica camera – that inspires Davidson's vision. His admiration for Cartier-Bresson is clear from Davidson's 'Time Line'.

Two other photographers from the Americas visited London at about the same time as Davidson. Sergio Larrain from Chile photographed London with poetic intensity and inventiveness and published *London, 1958-59* 40 years later (1998). He was fascinated by the top-hatted bankers of the City, but also interested in the ethnic diversity of London and in its transport system. His take differs most markedly from Davidson's by being as engrossed in formal experimentation – such as unusual viewpoints and juxtapositions,

plus thick grain. Whereas both photographers saw London as poets, Davidson's extended take also offers sustained description as well as formal excellence.

While Larrain and Davidson favoured the small-camera aesthetic of the Leica, a very different approach characterises the contemporary photographs made by Evelyn Hofer and published as *London Perceived* (1962). Hofer's allegiance was to the portrait style of August Sander (1876-1964) and the tradition of the plate camera on a tripod. Her portraits of London types and locations, in colour and black and white, are fine-grained in every sense. Only once do we see a London fog. Davidson chose to photograph 'sur le vif', revelling in London's atmosphere and giving us the illusion of capturing unselfconscious life in its uncertain habitats.

This book opens with two bankers, one tall and one stout, strolling past the Bank of England. They are silhouetted against a patch of white Portland stone which has unaccountably escaped the darkening effects of soot and rain. The men are descendants of the jaunty City clerks Charles Dickens so enjoyed describing. The street is virtually empty of cars. In 1960 there were 75 million privately-owned cars in the US, while the figure for Great Britain stood at a lowly 6.5 million (against populations of 179 million and 53 million respectively). Davidson was to photograph noticeably car-less streets in the north of England.

The second photograph, of a woman cleaning a marble floor, takes a theme on which Brandt made a powerful photograph – in his *Bethnal Green housewife* (1937). However, while Brandt's image was lit by feminine beauty and consecrated to domestic self-respect, Davidson's shows us an elderly worker surrounded by the tools of her trade and apparently pausing to catch her breath. Work and workers, many of them female, are one of the themes of Davidson's coverage. Whereas Brandt introduced artificial light when he deemed it

necessary, here Davidson followed Cartier-Bresson in preferring the difficulties – but compensating authenticity – of ambient light.

The photograph on page 15 shows a car park in bomb-damaged London. This one accommodates the small boxy British cars of the time – such as the Ford Popular – alongside a two-tone Bentley in the foreground. Among the ragged walls, a man stoops to pat a dog. This kind of photograph recurs in Davidson's take. He finds a satisfying geometrical motif and waits for whatever contingency will animate it. Of course, there's always more to it than geometry – Davidson points out to me that he was drawn to 'the juxtaposition of the bombed out buildings falling to pieces with the expensive cars parked within'.

As David Hurn reminded me, when we looked at Davidson's photographs, a photographer visiting a foreign country 'has an enormous advantage for a month or two – they see what is *ordinary*'. Thus, British photographers generally did not see or take the kinds of picture characteristic of this book. Tony Armstrong-Jones (later Lord Snowdon) photographed for *The Queen* and memorably captured the English nanny, just as Davidson did. However, such set-pieces are out-numbered by photographs which describe what is so ordinary to natives that it is invisible. Coming not only from a 'new country', but New York, Davidson was highly-tuned to 'ordinary' Britain.

The image on page 21 presents a cool, 'contemporary' Britain, with hard-edged, allusive advertising. The horizontal stroke of the number 5 in the Guinness poster also represents a foaming glass of stout. Modernity was not of the greatest interest to Davidson. He saw it as an element in what Henry James called the 'thick detail of London life'. What appealed to him in this elegantly organised photograph – in five stacked bands of information – is the juxtaposition of modernity and the archaic. The men among the seated, hatted figures are brothers to the old countrymen I recalled at the beginning of this essay.

Davidson vividly recalls one of his most finely seen London subjects (28): 'I first saw him from across the street bending over screwing in a prosthetic forearm that had fallen off his upper arm onto the pavement. Before I could come to his aid, he had re-joined it and was off crossing the street toward me. The elderly gentleman represents the British character quality of making do and going on no matter what. Stiff upper lip....' Another photographer might have interpreted the encounter very differently. Instead, we have one of the most tender and poetic images of the time.

Elsewhere, Davidson seizes such contrasts as three elderly women, wearing coats cut in a style still reminiscent of war-time 'Utility' patterns, inspecting the luxurious interior of a limousine (30). The same State occasion yielded other photographs involving the act of looking, complex reflections, and deference. Is that Lord Mountbatten in the limousine (32)? Davidson's photograph not only conveys the atmosphere of a large and varied crowd of onlookers, but isolates the extraordinary sight – to modern eyes – of a distinguished-looking man raising his hat as the commander rides by. Soon, hats would neither be doffed nor even worn.

Davidson did not seek out areas of high immigrant population like Notting Hill, where race riots took place in August 1958. His photographs of London include only one black man. He appears on page 33 seated aboard that typical symbol of the city, the double-decker bus. The composition may seem superficially reminiscent of the famous *Trolley-car, New Orleans* in Robert Frank's book *The Americans* (1959), but Davidson was unaware that there was a black man on the bus when he was taking this photograph. The passengers and the cyclist are shown witnessing some spectacle that makes them all look up.

Davidson often shows us the 'ordinary', doing so with unusual grace: page 34 is as much a portrait of a bus ploughing through a

foggy London street as it is of a young girl's pious donation to the Salvation Army. Page 35 captures a smoky train shed typical of the age of steam. Sights like the postcard-seller with his stock of the city's principal monuments, presided over by the image of Queen Elizabeth II (39), allowed Davidson to show how the London fog blanketed everything. After successive Clean Air Acts the fogs abated and the walls were gradually cleaned.

In his image of a large lady dancing with a short but game man before an appreciative crowd (42), Davidson emulated a stand-by of British humour, from the postcards of MacDonald Gill to the Al Read Show on BBC Radio. Here and there in the London photographs we see seeds of the Sixties: the war veteran on page 43 is framed by a young woman in a printed plastic raincoat and a young man in a Windsor-knotted tie who would – in 1960 – have attracted the half-admiring, half-derisory epithet 'smooth'. Note too the 'streamlined' basket on page 47.

Davidson humorously describes himself as being 'thin, quick, quiet, and cute' in 1960 – adding : 'I also could say thin to be unseen, quick without intruding, quiet but listening, and cute which I was unaware of'. His speed of thought and mastery of his medium allowed him to anticipate and capture pictures which cram the frame with content while simultaneously composing the information for ease of legibility and balance on the page. Thus, his shot of Piccadilly Circus (48) elegantly juxtaposes a traditional sandwich-board man – his thumb adding emphasis – with neon flashing from the screen of a cab.

He was able to work both inside and outside pubs and restaurants in low light conditions. A bar photograph (50) observes the stratagems by which strangers examine each other in public places. The woman cups her chin in her hand, ready to pass it over her face while she steals a glance. The sailor cannily uses his beer glass – its rim at the level of his eyes – to disguise a gaze in her direction. The panelled pint

glasses set up a little visual rhyme with the bar's panelled windows. The shape of another stranger looms at the left.

Davidson recorded a sight familiar in 19th and 20th century London – an all-night coffee stand, probably in Covent Garden, which was then still the centre of Britain's fruit and vegetable wholesale trade (52). T.S. Eliot refers to such stalls in his poem 'Preludes'. This was the momentary meeting place of those who were finishing partying, those about to start work, and perhaps the odd existentialist writer who is up all night anyway – like the man in the dishevelled raincoat who seems to embody 'The Outsider' (to recall a term made current by Colin Wilson's eponymous book, published in 1956).

Elsewhere Davidson captures a 'spiv', a typical word from the time, in signature trilby hat, innocently parading musical toys – his suitcase ready to be closed at once if a policeman approaches, which is why the boy behind him keeps watch (51). Other photographs grab not only a street snog, another great word from the period, but also the must-wear fashion requirement, winkle-picker shoes (53). We have denim jeans, the juke box and the Top Twenty – note the shirt-collar worn turned up in the style of Elvis Presley and James Dean (54), and a bottle-blonde beehive (55).

The most-often reproduced of Davidson's London photographs is on page 57. He recalls meeting the girl with her friends (56) in the street (it looks like Soho) by chance. After photographing them – first as a group and then the girl alone – he accompanied them to a place where loud music was being played. Davidson soon left. He recalls that the girl and her friends were on their way to a concert on an island. (This was not the Isle of Wight Festival, which only began in 1968.) Davidson's photograph captures a young woman poised between childhood and the adult world, while her *gamine* hair places her androgynously between the sexes. If the kitten she cradles looks back to childhood, the sleeping-bag slung over her shoulder asserts

independence. Car head-lights pop around her in the dusk, rhyming with her large eyes. Perhaps, without condescending to her individuality, we can say that this young woman also symbolises many others. She recalls a type defined and analysed by Peter Laurie in his book *The Teenage Revolution* (1965): 'The real dynamo behind the teenage revolution is the anonymous girl from twelve to sixteen, nameless but irresistible'.

This remark was quoted by Dominic Sandbrook in *Never Had It So Good*, from which I have already quoted. Sandbrook's thesis is that historians of the period 1956-64 have been overly-influenced by the memories of a metropolitan cultural elite. Thus, he writes in his concluding chapter, 'historians have tended to exaggerate the extent and speed of change in Britain during the sixties, and to ignore the numerous cultural and political continuities that stretched back to the thirties and even beyond'. Davidson's photographs, apparently the works of an impartial as well as observant outsider, provide evidence in favour of Sandbrook's view.

As if to demonstrate his range of interests and sympathies, Davidson immediately turns from sexy, freewheeling youth in Soho to photograph the impressive face of an elderly woman seated in a café (58). She appears to belong to the world of British working-class life in the middle of the 20th century that was so carefully reconstructed by Mike Leigh in his film *Vera Drake* (2004) – but was so seldom photographed. This world plays an increasingly large role in Davidson's photographs as he moves out of London – to Hastings, Brighton, then Whitby and especially when he photographs in Scotland.

To today's cool, metropolitan generation, 'sidecar' means a cocktail. Davidson's photograph of a motorcyclist – with a passenger in the sidecar beside him – reminds us of the popularity of this means of transport in the Age of Austerity (64). While *The Queen* ran a famous 'Boom!' issue on 15 September 1959, that asked 'When did you last hear the word austerity?', the nation at large lagged behind the financial euphoria of the metropolitan elite. The artist Rolf Brandt once told me that he felt the Second World War had not really ended until 1951. Food rationing lasted three more years.

Davidson also captured the popularity of the weekend trip to seaside and Beauty Spot. Such expeditions differed from similar leisure trips today because the Sunday Best was required in those days. Formal clothing, worn on the day off, provided maximum contrast with the days of the working week and indicated a sometimes painfully-won and maintained respectability. Many photographs record awkwardly spread-eagled bodies encased in pressed dark suits, with braces, collar and tie. The legacy of Davidson's photographs of this subject may well include, as David Hurn suggested to me, the later representations by Elliot Erwitt and Tony Ray-Jones among others. He clearly relished the formality he found in the game of bowls he photographed so tenderly, and the delightful humour and comradeship he noted among its women players (78-81). In Brighton he photographed a young couple riding a scooter – Italian Lambrettas and Vespas provided economical transport at the time – with a streamlined sidecar for their baby (84). Without over-interpreting the photograph, surely we notice at once that it is the woman who drives and this signals that new negotiations between the sexes were in the air. Their similar hair-styles remind us that Unisex hair-dressing establishments were coming soon.

Davidson became adept at photographing from his car (85, 91). As he drove through the North of England and into Scotland he made landscape pictures that are as raw as the livelihoods he photographed (88, 89), like that of the gamekeeper swinging across the moor, crook in hand, on page 90. The remote areas through which he travelled prompted Davidson to make minimal landscapes (96, 122). They are

reminiscent of some of Bill Brandt's austere interpretations of Thomas Hardy's 'Wessex' in the 1940s – and they look ahead to the spare poetry of Raymond Moore's late landscapes of the 1970s and '80s. He also caught the strenuous work of Scottish fishwives (118, 119) with an almost expressionist forcefulness. He captured the fishwives' immersion in their hard task in such a way that we know that this labour has been handed down the generations immemorially. His photographs of turnip or worzel picking (94, 95) convey not only the sheer arduousness of such labour but the communal life of subsistence farming in which men, women and children – the whole family – all work together. His portraits of farmers (92, 93), postwoman (116) and shepherds (125-127) evoke lives of austerity and endurance in compositions of great power.

Davidson brings down the curtain on *England / Scotland 1960* in style – with a portrait of Queen Elizabeth II projected onto the ruched curtains of a cinema at 9.52 pm. The caption does not say where the photograph was taken but perhaps the point is that it could have been taken anywhere on Davidson's travels. Not only was the monarch's portrait projected, but the national anthem – incredible as it may seem now – was sung by a standing audience at the end of each last performance. This says something about a culture of patriotism and deference, but makes another point.

This essay opened with, and has from time to time returned to, the question of what 1960 felt like and looked like. The final photograph reminds us that although our view of the time may – perhaps

inevitably – have been conditioned by the memories of a metropolitan elite, the country as a whole was reached by mass-media. It was entertained and informed by magazines like *The Queen*, of course, but – much more significantly – it was enthralled by cinema. We see the signs of this throughout the series: even a pub or 'Men's Club' (later renamed social clubs) in rural Scotland (110) includes an announcement of screenings of Bert Stern's classic documentary *Jazz on a Summer's Day* (1959) and Elia Kazan's *Wild River* (1960). The old men in the pub were served by the same mass media as the Duke of Argyll and his guests (112, 113). The wife of the Highland piper (115) has a pompadour styled in Hollywood, just as the Soho girl seems to have modelled herself on Lesley Caron. With remarkable lyrical intensity, Davidson's photographs show us many things about our country – including how what we think of as modern or archaic coincided.

Davidson's 'picture essay on Britain' appeared as 'Seeing Ourselves As An American Sees Us' in the issue for 12 April 1961. Astonishingly by today's meagre standards, 27 Davidson photographs ran over 22 large pages. They were accompanied by aptly chosen quotations from classic writers, from Robert Burns to Olive Schreiner. The essay created no particular furore at the time. Nor was there a fuss when the story appeared the following November in the US journal *Horizon* as 'The New Face of Britain'. The photographs occasioned no criticism, I think, because they were convincing. As they remain, surprisingly, 45 years later.

This book is dedicated to Cornell Capa

Cornell Capa was instrumental in obtaining this assignment for *The Queen* magazine in 1960. In the early 1950's he had been a staff photographer for *LIFE* magazine based in London just after the war and had a fond memory of the British people. Cornell has been a mentor to many emerging photographers, including myself throughout my career. As director of New York's International Center of Photography, which he founded in 1974, he initiated several exhibitions of my work including *Bruce Davidson Photographs, 1956 to 1978*, and *Subway*, 1984. Later, *Brooklyn Gang* was shown in 1998 and most recently *Time of Change – Civil Rights 1961-1965*, both of which were organized and curated by Willis Hartshorn, Director of the ICP, and Brian Wallis, Director of Exhibitions, in conjunction with the blessing of Cornell.

When I first saw Henri Cartier-Bresson's *Decisive Moment* in 1952 while a photography student at the Rochester Institute of Technology, it inspired and instructed me with its sense of vitality and a suspended motion that caught reality. It was a way I wanted to explore life and express my feelings. I first encountered early Robert Frank photographs as a student. Frank's profound images of Welsh coal miners were in stark contrast to the prosperous bankers wearing top hats in the gray light and dense fog of those London streets and together they embodied an ironic, poetic vision that was both powerful and beautiful.

I also wish to thank John Hillelson, the Magnum agent at the time in London, who facilitated the assignment, and Jocelyn Stevens and Mark Boxer at *The Queen*, who all lent their support during the months I explored England and Scotland.

Mark Haworth-Booth while writing a text for this book asked insightful questions and looked at this imagery in terms of British history and photographic art. I was privileged to be able to work with Gerhard Steidl who is a most decisive publisher and who demands high quality reproduction. Michael Mack, Steidl's editor in London, made important decisions with respect to producing this book material.

I also wish to thank Sara Macel who helped me organize the material for this project, and Jill Thomas who worked with me editing my timeline text. Also thanks to my dear wife Emily who has made many important suggestions along the way and has lent her critical eye to the sequencing of these images and to the text itself.

Dominique Green, Director of Magnum London, and the staff at the London office have been most helpful as have Mark Lubell and his staff at Magnum New York. And finally, I send thanks to Diane Dufour, Director of Magnum Paris, who first showed this body of work to Gerhard Steidl. That encounter made the book a reality.

First edition 2005

Copyright © 2005 Bruce Davidson for the images
Copyright © 2005 Bruce Davidson and Mark Haworth-Booth for the texts
Copyright © 2005 Steidl Publishers for this edition

Edited by Bruce Davidson and Michael Mack
Book design by Bernard Fischer and Gerhard Steidl
Scans by Steidl's digital darkroom
Production and printing by Steidl

Steidl
Düstere Str. 4 / D–37073 Göttingen
Phone +49 551-49 60 60 / Fax +49 551-49 60 649
E-mail: mail@steidl.de
www.steidlville.com / www.steidl.de

ISBN 3-86521-127-5
ISBN 13: 978-3-86521-127-9

Printed in Germany